S0-AXN-612

Singapore Sketchbook

Graham Byfield

TOWARDS A TROPICAL CITY OF EXCELLENCE

Artwork © Graham Byfield, 1995, 1999
Text © Gretchen Liu
and Graham Byfield, 1995, 1999

Design and typography
© Editions Didier Millet, 1995

First published 1995
Reprinted 1996 (twice), 1997, 1998,
1999 (twice)

Published by Archipelago Press,
an imprint of
Editions Didier Millet,
64 Peck Seah Street
Singapore 079325

All rights reserved. No part of this publication
may be reproduced or transmitted in any form
or by any means, electronic or mechanical,
including photocopy, recording or any other
information storage and retrieval system,
without prior permission in writing from the
publisher.

ISBN 981-3018-08-9

Editor: Tim Jaycock
Art Director: Tan Tat Ghee
Designer: Tan Seok Lui
Production Manager: Edmund Lam

Colour separation by
Colourscan Co Pte Ltd.
Printed in Singapore by
Tien Wah Press (Pte) Ltd.

The publishers would like to thank the **Urban Redevelopment Authority** for their generous support and active encouragement which made this book possible.

ARTIST'S ACKNOWLEDGMENTS

This book is the culmination of a decade-long love affair with Singapore's architectural heritage. As a newly arrived art director off the plane from Europe in the mid 1980s, I was enchanted by the style and scale of the island's old buildings. Soon I was spending many weekends painting them. As I continued to sketch and paint over the years, I was also eyewitness to Singapore's conservation programme. Gradually the idea took shape of doing a book that would record the many changes. Along the way, many people generously gave their support.

I would first like to thank the Singapore Tourist Promotion Board, the Economic Development Board and Urban Redevelopment Authority for their encouragement and interest, especially STPB's Chairman Edmund Cheng and Pamelia Lee. Richard Helfer, CEO of Raffles International, has always been a keen supporter of my work as well.

In putting the book together, I am indebted to Didier Millet and Charles Orwin of my publishers who were positive from the first. Then came my friend, writer Gretchen Liu, who has written the text with such knowledge and depth. Our joint efforts have, I hope, produced an unusual and enjoyable record of restoration. To Tim Jaycock, my editor, thanks are due for his endurance with the fax machine, the main means of communication with my studio in Spain, and for checking everything so thoroughly.

Heartfelt thanks also go to Jayne Norris and Robert Henley for their kind hospitality during my visits, to Don Siegel and Joyce Ho of Hofun for their help in organizing some of my earlier paintings and last, but certainly not least, to my wife Hanna, who spent so much time proofreading the hand-written captions.

Finally, I am very grateful to the friends and acquaintances who allowed me to paint their homes for the book or allowed us to reproduce earlier works. These include the British High Commissioner Gordon Duggan and his wife Erica, Revd Ronald Pederson of the Danish Seaman's Church, Raffles International for Clarke Quay, former United States Naval Attaché and his wife Mr. and Mrs. George Lundy Jnr who have never forgotten their Nassim Road home, Peggy and Torseng Lee for their fine cottage by the sea, Emerald Hill residents Richard Helfer and Dr. Geh Min, Mr. and Mrs. Ian Batey for their painting of Petain Road, Albert Lim for his house at No. 12 Koon Seng Road, Alexandra Park residents Jayne Norris and Robert Henley, Martin Edwards and Esme Parrish and Mr. and Mrs. P. Sanderson for showing me Winchester School and the Botanical Gardens, and in Ridley Park, Mr. Alistair Smith Laing.

Singapore Sketchbook

Paintings by Graham Byfield
Text by Gretchen Liu

ARCHIPELAGO PRESS

Contents

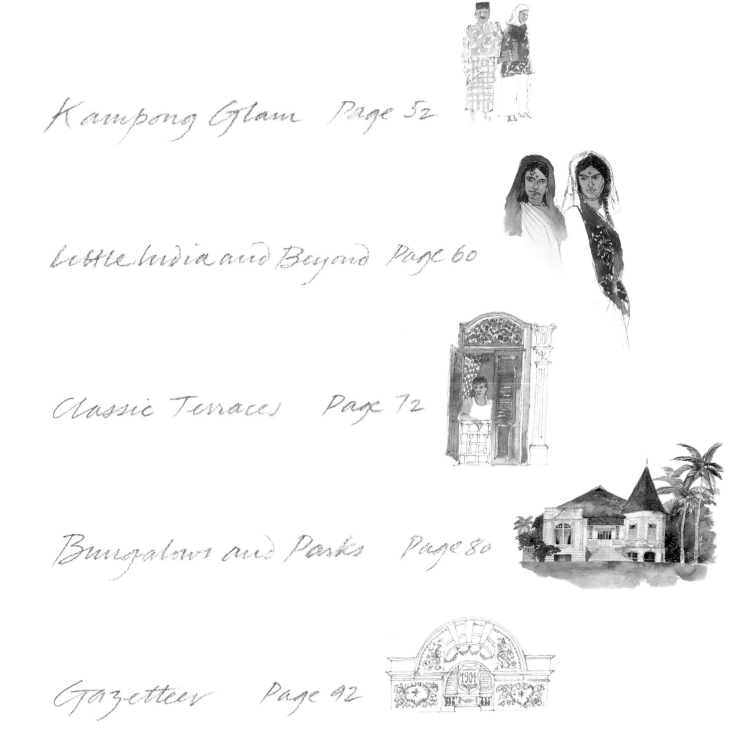

Introduction

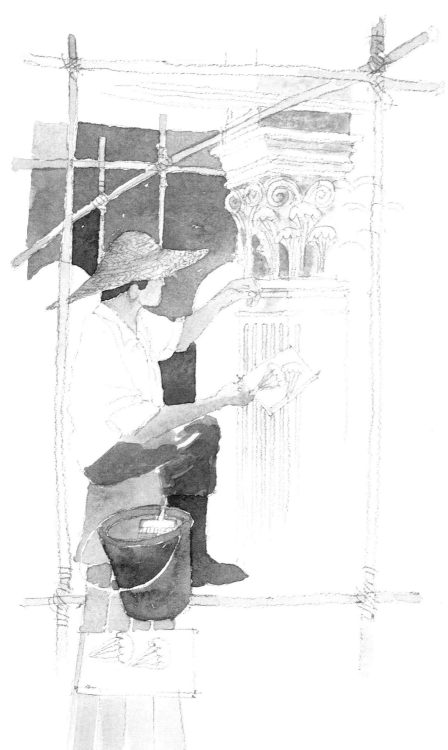

The initial impression Singapore often gives is of a modern city that has very little interest in, or patience with, its past. But a leisurely walk through the areas featured on the pages of this sketchbook might convince you otherwise. Such a stroll would take you past busy and well-kept 19th-century temples, mosques and churches, neat rows of pastel-painted shophouses, an eclectic variety of colonial, civic and commercial structures and converted riverside godowns — all the visible reminders of the bustling trading port once dubbed the 'Clapham Junction of the Eastern Seas.' Today, these buildings share the skyline with skyscrapers that signal late 20th-century economic progress. Architectural heritage and prosperity sit comfortably side by side.

That the past and present respectfully coexist is largely due to developments sparked by the unveiling, after intensive research, of a Conservation Master Plan by the Urban Redevelopment Authority (URA) in 1987. This laid out guidelines for the restoration and reuse of historic structures and paved the way for the revitalization not only of individual structures, but of streets, areas and the three unique historic districts of Kampong Glam, Little India and Chinatown, which hold a special place in the hearts of all Singaporeans. By early 1995, some 5,319 buildings had been gazetted as conservation properties. Of these, some 1,234 had been restored.

The flourishing of old buildings in a small, land-scarce city state, where rapid change and an unsentimental approach to the past have been the norm, is but the latest chapter in the story of Singapore's architecture, urban growth and renewal, a story that

commenced 170 years ago with the establishment of a British port on a jungle-covered island inhabited mostly by Malay fishermen living along the coast in attap huts.

RAFFLES' VISION

Modern Singapore is a relatively young city. Like the other former British colonial ports of Bombay, Calcutta, Hong Kong, Sydney and Shanghai, it took root and flourished where nothing else existed before. At its founding, it was largely the brainchild of one man: Sir Thomas Stamford Raffles. The many-talented British East India Company official sailed into the Singapore River and signed a treaty with the local chieftain, Temmenggong Abdu'r Rahman of Johore, on 30 January 1819. The treaty granted a strip of land along the coast to the British. A second treaty, signed between the Sultan and the East India Company in 1824, handed over the entire island.

Raffles' objectives were free trade and the extension of British influence in the East. His mission was to establish a strategically located British 'factory' (the old-fashioned word for trading post) in the Malacca Straits, which would compliment British settlements in Penang and Bencoolen and compete with the Dutch who were firmly entrenched in Batavia and Malacca.

Raffles did not linger. He made only three visits between 1819 and 1823, which added up to less than a year's stay. Yet he was an idealist, with a town planner's sense of discipline and the will to impose it. This he did in 1822. Arriving after an absence of three years Raffles was greeted by urban chaos caused by a swelling population, instead of the neat 'pride and Emporium of the East' he had so confidently envisioned. With the help of the young Lieutenant Jackson, the Garrison Engineer, and a Town Planning Committee, he devised a town plan of which the imprint is still visible to this day.

The cornerstone of Raffles' plan was the division of the town into separate districts, each with its own function. The seat of government was allocated the flat north bank of the Singapore River, the commercial district land along the south bank.

Although wealthy Asian and European merchants were encouraged to trade side by side, and could live according to their means wherever they liked, the majority of the population was settled into segregated communities. Europeans were directed to the area abutting the government district. The Chinese who, Raffles rightly anticipated, would compose the largest single group were relocated south of the river beyond the commercial area in what is today's Chinatown. The Sultan and his followers were given land in Kampong Glam and here Arabs, Bugis and other Muslims were encouraged to settle.

The plan also provided for a botanic garden, buildings for education and religious worship, for a network of roads and streets of specified widths to be laid out at right angles and for the subdivision and sale of uniform plots of land. In the town area, Raffles proposed a linear arrangement of commercial buildings and linked shophouses of specified widths and uniform façades not exceeding three storeys. A 'five-foot way', an arcaded covered passageway, was introduced 'for the sake of regularity and

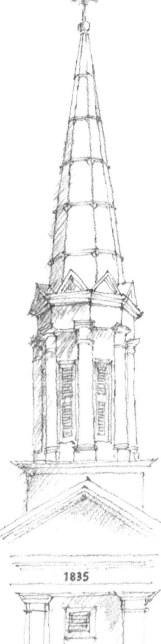

1835

G. D. Coleman's Armenian Church.

conformity' as well as weather protection. Buildings were to be constructed of brick, with tiled roofs and solid foundations.

The stringent building regulations soon gave rise to the neat townscape of spacious bungalows and tidy narrow shophouses built in stuccoed brick, which was so well captured in the early prints and photographs of Singapore.

COLEMAN'S LEGACY

The second person to have a significant impact on the fledgling settlement was the architect George Drumgoolde Coleman, who was immediately involved in several of the projects commenced by Raffles. An Irishman from Drogheda, Coleman had studied architecture in Dublin, travelled extensively throughout Europe and was well-versed in the vocabulary of classical architecture by the time he arrived in Calcutta in 1815. His path to Singapore in 1822, as a youthful 27 year old, was via Java where he had been commissioned to design a cathedral — a project never carried out.

Coleman returned to live in Singapore in 1826. For the next 15 years he was engaged by the government to carry out revenue and topographical surveys and to lay out and construct roads and bridges. In the 1830s he was officially appointed Government Surveyor, and in 1833 he became Superintendent of Public Works, Overseer of Convict Labour and Land Surveyor.

At the same time, he maintained a flourishing private practice as an architect and contractor. Not only did he build the majority of the elegant, airy houses commissioned by the Europeans, but he was also responsible for places of worship (for

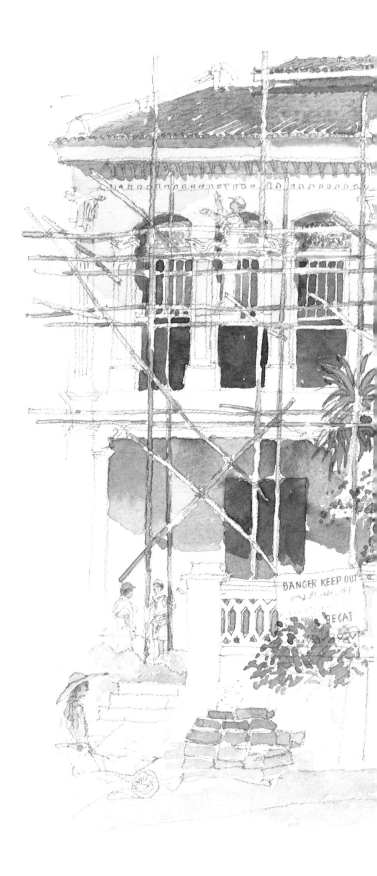

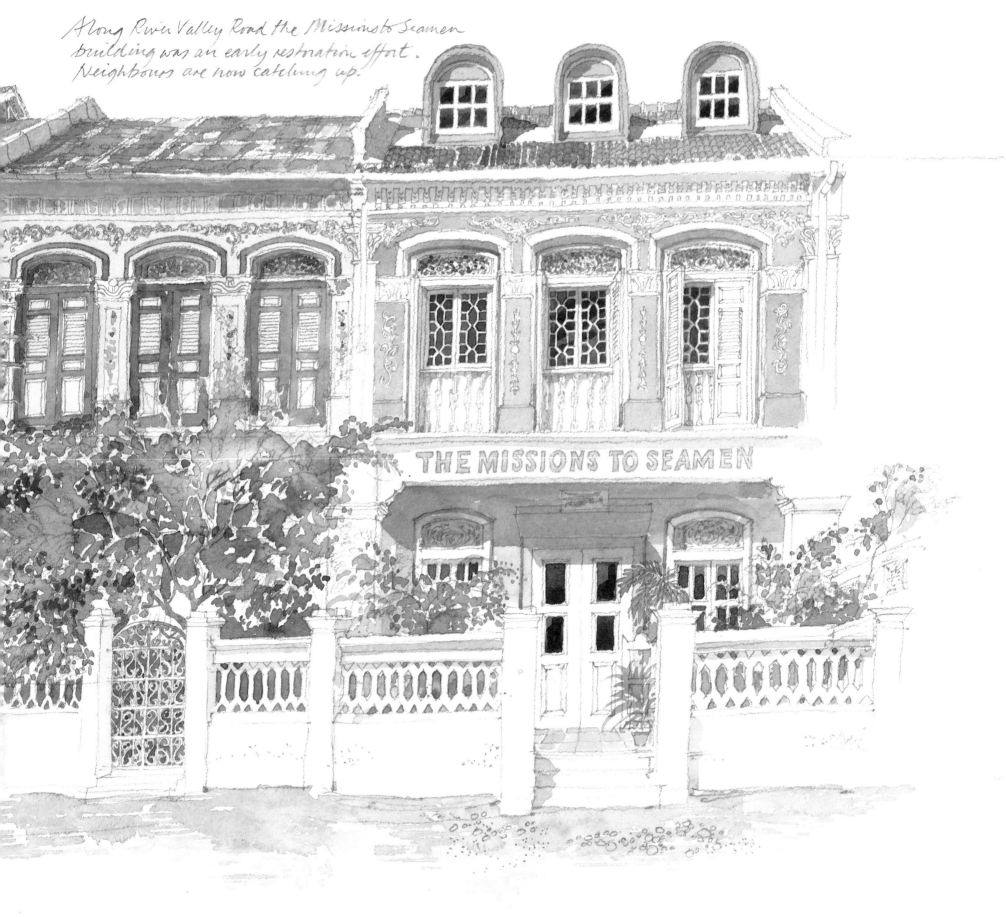

Along River Valley Road the Missions to Seamen
building was an early restoration effort.
Neighbours are now catching up.

THE MISSIONS TO SEAMEN

example, the Armenian Church and the first St. Andrew's Church), places of education (such as Raffles Institution) and several commercial projects (including Bousted's godown and the first Telok Ayer market). On the street which bears his name, even today, he built his own grand residence.

Coleman, who died in Singapore in 1843, set high standards for domestic architecture. By the 1860s there had evolved a simple elegant style which conformed to English traditions but made concessions to the tropical climate. The style persisted well into the 20th century, although changes began to occur in the 1870s with the influence of Victorian eclecticism.

TAMING THE JUNGLE

By the 1860s, an air of permanence had settled over the new town area. One indication of this was the flourishing of religious buildings as more immigrants settled, and trade and commerce expanded. To replace the wood and attap huts that had served for temples, mosques and churches, the various communities now found the time, money and energy to commission permanent places of worship — including the Armenian Church (1835), the first St. Andrew's Church (1836), the first Roman Catholic church (1883), Thian Hock Keng Temple (circa 1842), Hajjah Fatimah Mosque (1846), the Sri Mariamman Temple (circa 1843) and the Jewish synagogue in Synagogue Street (1845).

The town still extended in very few points more than a kilometre and a half (about a mile) from the beach, even though the population had doubled, from 35,000 in 1840 to 81,000 in

1860. The increased density was especially felt in the ethnic quarters but even the main European residential area around Beach Road and the Esplanade was becoming more crowded and less desirable. By the 1860s, many of the large bungalows, including those designed by Coleman, were being converted into boarding houses and hotels to cater to the new breed of globe-trotter travelling for pleasure. Established residents were moving to the now fashionable residential districts of River Valley Road, Killiney Road, Orchard Road, Claymore and Chatsworth.

Nevertheless, the town continued to present a tidy appearance that was commented upon by many travellers, including John Cameron who observed, in *Our Tropical Possessions in Malayan India*, published in 1865: 'The town ... being remarkably compact, the country may be said to come right up to its walls. There are none of those intermediate half-formed streets, with straggling houses here and there, separated by blank, barren open spaces, which so often disfigure the outskirts of a town. Where the town ends, the country commences; indeed it would be difficult for a piece of ground to remain long desert, for nature would soon crowd it with her works, if man did not with his.'

It was the agricultural entrepreneurs who tamed the jungle. Nutmeg, in particular, was the rage, although gambier and pepper were popular as well. The first Europeans to open nutmeg plantations, in the 1830s, were: Dr. Thomas Oxley, who purchased a whopping 70 hectares (173 acres) of uncleared jungle from the East India Company, and formed the Killiney Estates; William Cuppage, an officer in the postal service who occupied

Back alley staircases are also subject to restoration requirements.

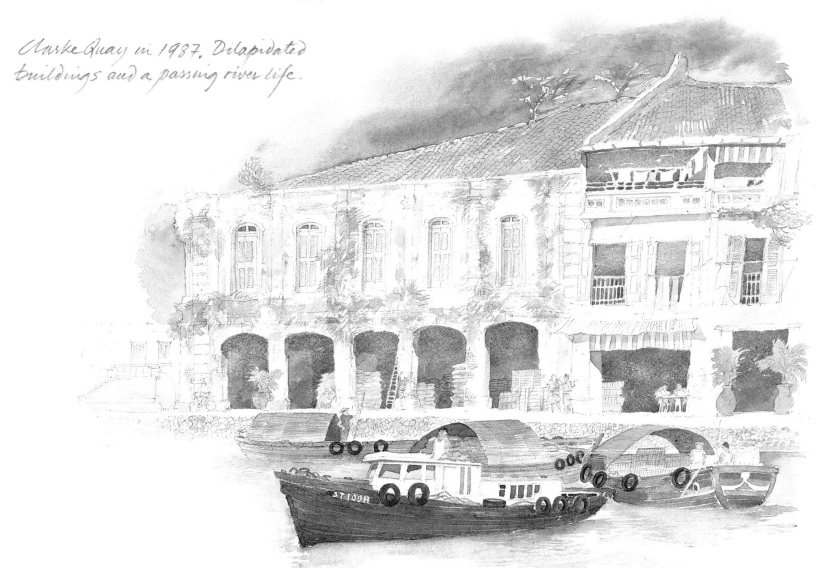

Clarke Quay in 1987. Dilapidated buildings and a passing river life.

Emerald Hill, and; Charles Carnie, a businessman who built the first house in Cairnhill in 1840. By the time the nutmeg trees succumbed to a blight in the 1860s, the estates stretched from Pasir Panjang to Adam Road, through Tanglin, Claymore and Bukit Timah Road. As a result of the blight, many of the owners retained their holdings but erected houses for sale or rental.

PORT CITY

We now come to an important new chapter in Singapore's architectural history, one that commenced auspiciously in 1867 when Singapore's status changed from that of isolated East India Company outpost to fully fledged British colony and seat of government of the Straits Settlements, which included Penang and Malacca. The move underscored the island's strategic importance, and it was not long before the first Governor of the Straits Settlements was ensconced in Government House.

Political events coincided with wondrous developments in transportation. The year 1869 saw the opening of the Suez Canal. Novelist Joseph Conrad, who had known the East

intimately as a young sailor, wrote of this engineering marvel, that 'like the breaking of a dam, [it] had let in upon the East a flood of new ships, new men, new methods of trade. It changed the face of the Eastern seas and the spirit of their life.'

Equally important was the commercial viability of steam navigation. Coal-fired steamships dramatically reduced travelling time on the world's oceans, from arduous and unpredictable months to reliable (and eventually luxurious) weeks. Singapore rapidly became one of the world's great coaling stations, 'the great junction where ... all who travel must stop and see what a marvel of a place British energy has raised from the jungle in half a century,' wrote Eliza Scidmore, an American, in the early 1890s.

By 1900, visiting writers were routinely chronicling the town's stately business houses, handsome banks and long iron pavilions shading the daily markets, the suburban roads embowered in lush greenery and the cosmopolitan population clothed in turbans and sarongs. For as trade boomed, so did the city.

There were large, landscape-altering projects, such as the construction of Collyer Quay in the mid-1860s, the land reclamation in front of the Esplanade to form Connaught Drive in the mid-1870s and the massive reclamation of Telok Ayer basin, 1879–1890, which provided direct communication between the town and the flourishing port facilities at New Harbour. The docks, coaling sheds and godowns of New Harbour had been carved out of mangrove swamp and it was here that new arrivals alighted to find themselves in the 'Liverpool of the East'.

Transportation also brought changes within the town. The old-fashioned, horse-drawn gharries and ox carts jostled along congested roads beside the tracks of, first, a short-lived steam tram and then, subsequently, a more successful, electric tram. The trams themselves were given stiff competition from the popular human-drawn rickshaws, introduced as public transport in 1881. As traffic increased, roads were improved and several new bridges made their appearance over the Singapore River.

There were notable architectural achievements as well. The Town Hall (1862) was grander and more extravagantly decorated than the earlier, chaste, Palladian buildings, and signalled the arrival of Victorian eclecticism. Other important public buildings included the Government Offices at Empress Place (1864-65) the first Singapore General Hospital (1882), Raffles Library and Museum (1887), the cast-iron Telok Ayer Market (1894) and the Police Headquarters and Police Court (circa 1890).

An impressive new generation of banks and commercial buildings also made their appearance. As it turned out, many of these structures lasted barely half a century as they were, in turn, replaced by yet larger piles in the early 20th century.

SUBURBAN EXPANSION

Singapore's rising prosperity coincided with the last unsettled decades of the Qing Dynasty. As word of economic opportunities spread, thousands of Chinese immigrants flooded the shores. Wealthy Europeans and Chinese built spacious villas away from the crowded city, while poor and indentured labourers crowded into shophouses turned tenements. The immigrants from China

were joined by Indians, Arabs and Europeans in search of fortune. By 1871 the population stood at 97,000; by 1900 at 228,000; and by 1921 at over 418,000.

The city began bursting out of its confines, stretching through swampy fields, jungle and coconut plantations, via new roads to Tanglin, Serangoon, Katong, Pasir Panjang and beyond. The expansion was radial, beginning initially as ribbon developments along main trunk roads such as Tanjong Pagar Road, River Valley Road, Orchard Road, Bukit Timah Road, Thomson Road, Serangoon Road and Kallang Road.

BOOM YEARS

The boom years continued, with only a few short interludes, from 1870 until the onset of the Great Depression in the 1930s. Around the turn of the century, they were further fueled by the enormous wealth created from the world-wide demand for two commodities that the newly colonized Malayan states could provide in abundance — rubber for the booming automobile industry and tin for the canning industry — and for which Singapore was the principal outlet and commercial port.

The pace of change accelerated. The number of motor cars increased, from 842 in 1915 to 3,506 in 1920, causing acute road congestion. The causeway to Johore opened in 1928, connecting Singapore by road and railway with the Malay peninsula. The first electric power station opened at St. James in 1927. The Singapore Cold Storage Company manufactured its first ice cream in 1920. A very grand Municipal Building (City Hall) was

Hand-crafted details, Raffles Hotel, 1990

Ornamental plasterwork so characteristic of Singapore's shophouse architecture.

completed in 1929. (Thirty years later, Prime Minister Lee Kuan Yew declared the independence of Singapore from its steps.)

As the value of land in the central area increased, new middle-class suburban areas were established in the 1920s. While Kampong Glam retained its Arab-Malay ambiance, Malay settlements scattered up and down the coastline, stretching eastward through Geylang to Katong, Siglap, Bedok and Changi, and westward to Telok Blangah, Pasir Panjang and Jurong.

The Indian community, which had long centred around Chulia and Market Streets, spread to High Street, Serangoon Road, to the railway and port areas at Tanjong Pagar and Keppel Road and to the naval base in Sembawang.

Although the English controlled the major banks and financing, most of the business concerns were in the hands of Chinese families. The more affluent settled in popular middle-class areas close to town, such as Neil Road, Blair Road, Spottiswoode Park, Killiney Road and Emerald Hill, where some of the elegant rows of terrace houses were built as speculative ventures. Wealthy Chinese favoured bungalows in Bukit Timah or seaside villas along the East Coast Road and Pasir Panjang.

The Europeans had not only become firmly entrenched in Tanglin and Holland Roads but their presence was extended as military bases were constructed at Changi, Alexandra, Ayer Rajah and Seletar.

The majority of the elaborate, eclectic, pastel-coloured shophouses and residential terraces, in the style variously referred to as Chinese Baroque, Straits Chinese or Chinese Eclectic, that are now so closely associated with Singapore's architectural heritage, made their full and refulgent appearance between 1900 and 1930.

ARCHITECTS

Until the 1880s, the vast majority of Singapore's buildings were the handiwork of skilled craftsmen and quasi-professionals who relied on traditional building methods and well-circulated pattern books. By the turn of the century the bustling port city offered sufficient building work to sustain a new kind of architectural practice, both larger and more sophisticated, with the introduction of technical innovations such as structural steel, reinforced concrete, electricity, modern sanitation and lifts.

This niche was admirably filled by the firm of Swan & Maclaren. The firm's leading designer for a critical 15 years, and probably the island's most potent architectural force since Coleman, was the talented Regent Alfred John Bidwell. Bidwell arrived in 1895 with excellent credentials. He had been placed on the honours list for design at his London school, worked for the London County Council and in private firms, then joined the Public Works Department in Selangor, Malaya.

Bidwell's talent is amply evidenced in the handful of buildings he designed which have survived and remain much admired: the Main Building of Raffles Hotel (1899) as well as the Bras Basah Wing (1904), the Teutonia Club (1900) now part of the Goodwood Hotel, Stamford House, Victoria Memorial Hall and Chased-El Synagogue (1905), the Singapore Cricket Club extension (1906) and St. Joseph's Church (1913).

WAR AND ITS AFTERMATH

During the Great Depression and Japanese occupation the rate of building sharply decreased whilst the population steadily increased. Thus although the city survived the war with relatively little physical damage from marching troops and overhead bombers, post-war overcrowding, unemployment and lack of housing took a much more serious toll. Even after the colony had regained its economic strength in the early 1950s, Singapore gave the new arrival an overwhelming impression of tattered buildings and faded houses. In short, a city that had passed its heyday.

Post-war housing conditions for the vast majority of the population were remarkably substandard. In the ethnic districts, especially Chinatown, shophouses were intensively sublet and chronically overcrowded. Behind a picturesque façade, a home for an entire family would be reduced to a small rented cubicle with squalid communal cooking and toilet facilities. The five-foot way now served as sitting room and playground. On the periphery of the city, squatter areas with no sanitation proliferated. Dwellings were constructed of old wood, discarded metal and whatever other material could be scrounged up, constituting fire hazards.

To prevent landlords from exploiting the housing shortage by charging exorbitant rents, a Rent Control Ordinance was passed in 1947 which, in effect, froze rents. This, however, had the adverse effect of making improvements to tenanted pre-war properties economically unattractive to owners.

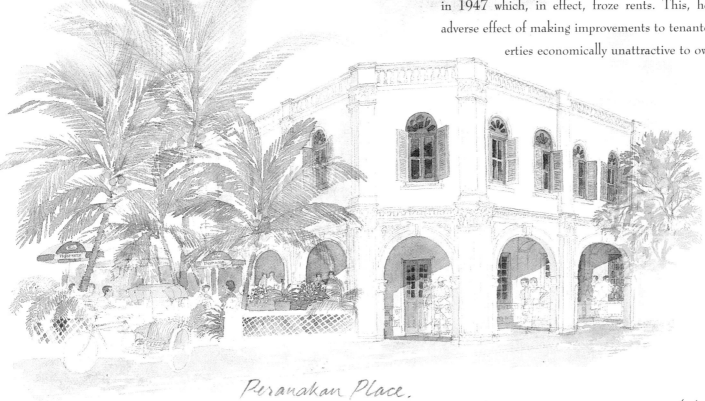

Peranakan Place.
An early restoration project.

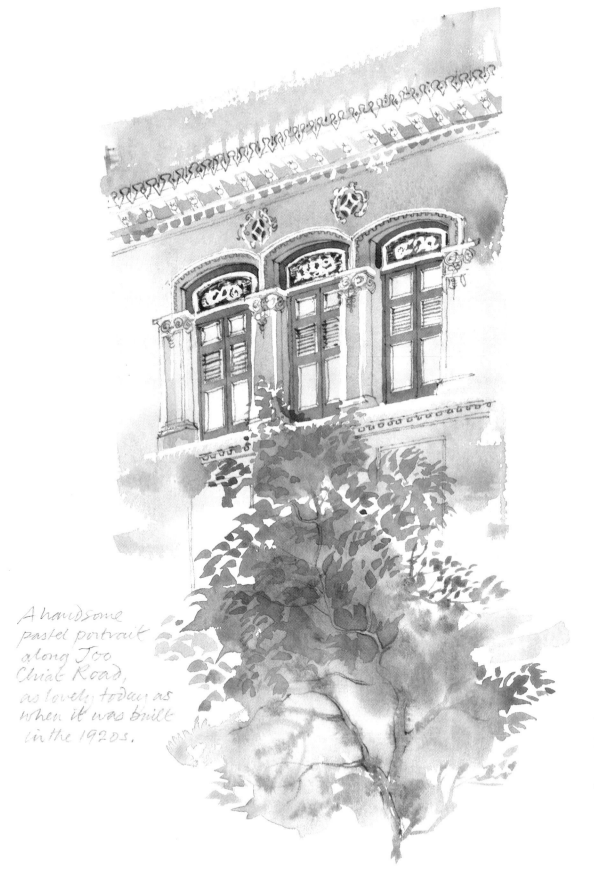

A handsome pastel portrait along Joo Chiat Road, as lovely today as when it was built in the 1920s.

HOUSING A NATION AND URBAN RENEWAL

In 1959 the colonial era finally ended. The People's Action Party came to power and the youthful Prime Minister Lee Kuan Yew assumed he would lead the newly independent island to prosper in union with Malaya. But on 9 August 1965 Singapore found that it had to pursue its destiny on its own.

Several acute problems faced the tiny nation of 1.6 million people. The decades of colonial rule had developed in many Asians a subservience that needed to be undone. A sense of belonging to Singapore, of common identity and unity had to be instilled in people who were accustomed to being cocooned in their different ethnic, linguistic and cultural groupings. On the economic front, there was serious unemployment, a severe housing shortage and insufficient infrastructure for an industrialized nation.

Singapore's strategy for survival and development was essentially to take advantage of the favourable factors in the world economy and its own strategic location through sound policies and firm direction. In terms of housing and urban planning, the success of this approach can be vividly seen in the achievements of the Housing and Development Board (HDB) and the Urban Redevelopment Authority (URA).

In 1960 the HDB was formed to tackle the housing problem head on. Its first five-year plan saw 51,000 units completed and soon the Board was well on its way to achieving the goal of providing homes for all Singaporeans.

Events which led to the formation of the URA began when a team of United Nations planning experts worked together with

their Singapore counterparts in the late 1960s to create a concept plan. This set the stage for urban renewal activities in the central area and the systematic planning of new developments elsewhere.

To expedite central area redevelopment, the URA was empowered to acquire land. Smaller plots were thus amalgamated into larger parcels that were sold by tender to the highest bidder and redeveloped into modern skyscrapers. Yet among government planners there was already a strong conviction that central area renewal and new construction needed to be balanced with the conservation of historic buildings. Care was taken in deciding which buildings were to be demolished, and in many cases only the most decrepit were taken down. Thus as public awareness of the importance of conservation grew in the 1970s, the city still contained many old buildings of merit.

MONUMENTS PRESERVED

Singapore entered the 1970s as a politically stable state with a high rate of economic growth. The basic problems of survival had been overcome. Once again, progress was rapidly reflected in a multitude of new buildings and infrastructure projects, from the impressive new skyline of downtown skyscrapers, to enormous land reclamation projects, industrial estates, a highway system, a new airport, recreation facilities and a Mass Rapid Transit system.

Amidst such developments, a Preservation of Monuments Board was quietly set up in 1972. Priority was initially given to religious buildings and institutions built by or associated with the early pioneers. By 1995 the list contained 34 monuments.

CONSERVING THE PAST

The interest in and appreciation for Singapore's historic buildings grew steadily, fueled by newspaper articles, by the restoration work of a few pioneering architects and through the publication of books on historical and architectural subjects.

In 1987 the Conservation Master Plan was unveiled. The plan nominated for preservation and conservation several large areas and more than 3,000 building of historical and architectural significance 'in order to safeguard them for future Singaporeans.' The Rent Control Act was finally dismantled and that, along with the gazetting of areas and buildings, gave many owners the confidence to invest in restoring their properties.

Following this healthy start, the URA — the national conservation authority — has continued its work, guiding the passing of new legislation, developing a systematic and comprehensive approach to conservation, refining conservation and preservation documents, publicizing practices and gazetting additional Conservation Areas and buildings.

Singapore has begun to earn international accolades for these ambitious conservation efforts, efforts which have not only rescued individual structures but harmoniously integrated entire historic districts, so appealing in their intimacy and human scale, into a textured urban landscape. The past and present are now comfortable neighbours.

CONSERVATION OF SHOPHOUSES
AT GT. 60 & 71
KEONG SAIK ROAD

FOR AUCTION

The Civic Spirit

The old stones of empire continue to thrive in the modern metropolis. Here ranked closely around the Padang — the green sward which once flanked the seafront but is now landlocked by a kilometre or more — are Parliament House, City Hall, the Supreme Court, Empress Place, Fullerton Building, and the Victoria Theatre and Concert Hall.

The buildings span just under a century of architectural history, from the Town Hall (1855), now Victoria Theatre, to the Supreme Court (1939). The exception is the riverside Parliament House which was built as a private residence in 1827, but never lived in, and subsequently taken over by the colonial authorities.

It was in the latter half of the 19th century that the pace of construction of public buildings accelerated. The boom was triggered by the 1869 opening of the Suez Canal and the transfer of rule from India to the Colonial Office in London, and was sustained by the burgeoning rubber and tin industries. Styles ranged from Palladian to Gothic Revival, Victorian, Edwardian, neo-Renaissance and Neoclassical. The architects were mainly engineers from the Madras Artillery who joined the Public Works Department or its earlier equivalent.

The Civic District also embraces historic churches, schools restored and adapted for new uses, museums, and a handful of commercial buildings that have withstood development pressures and road widening. Commanding one end of the Padang is the Cricket Club. A stone's throw away from the club is the historic Raffles Hotel. Exquisitely restored, the hotel is once again airy, elegant and, to borrow a quote from a visitor in 1907, 'one of the architectural ornaments of Singapore'.

Caldwell House, one of Singapore's oldest remaining houses, built in 1841, survived within convent walls for over a century. It was restored together with the whole convent grounds and is now known as Chijmes.

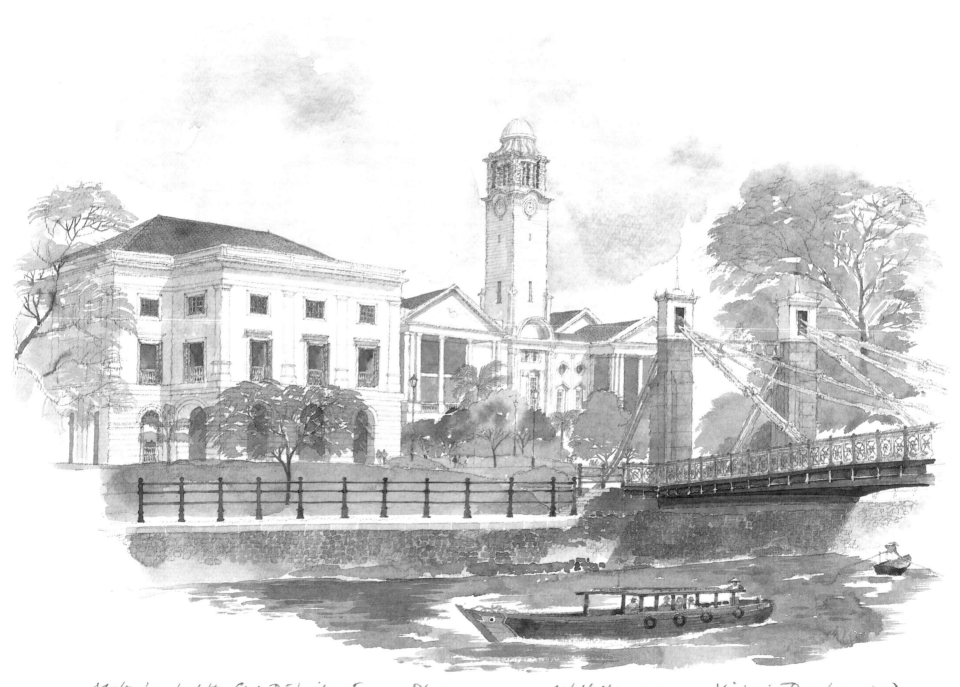

At the heart of the Civic District is Empress Place. The former government office perched on the river bank was one of the first old buildings restored in the 1980s, and was given a new lease of life as an exhibition venue. Victoria Theatre and Concert Hall, joined by the 60 metre (66 yard) clock tower in 1905, are even popular with theatre and concert goers.

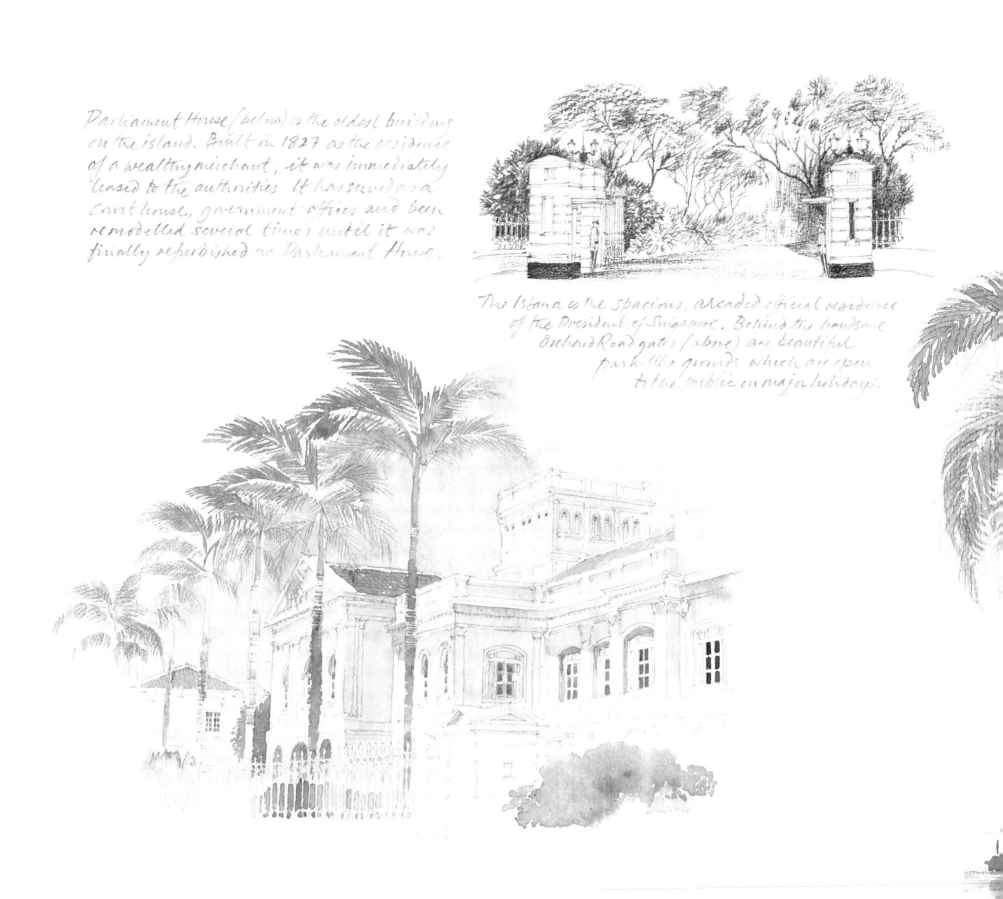

Parliament House (below) is the oldest building on the island. Built in 1827 as the residence of a wealthy merchant, it was immediately leased to the authorities. It has served as a court house, government offices and been remodelled several times until it was finally refurbished as Parliament House.

The Istana is the spacious, arcaded official residence of the President of Singapore. Behind the handsome Orchard Road gates (above) are beautiful park-like grounds which are open to the public on major holidays.

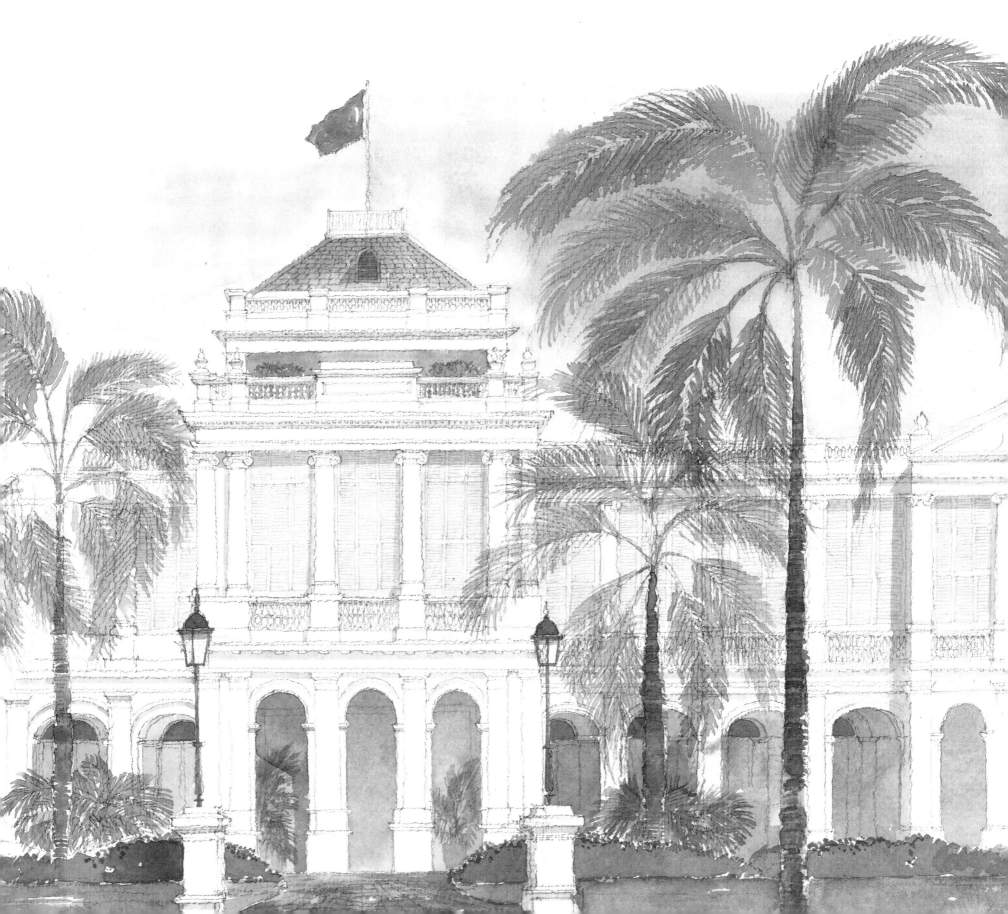

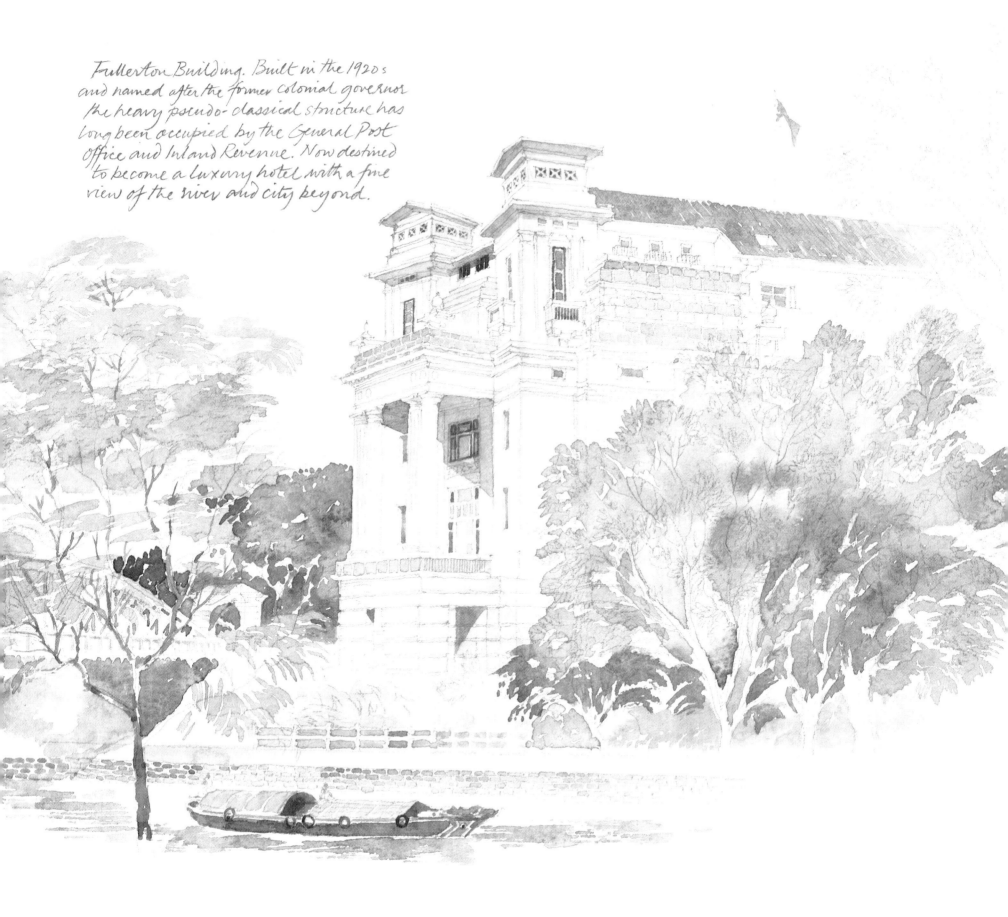

Fullerton Building. Built in the 1920s and named after the former colonial governor the heavy pseudo-classical structure has long been occupied by the General Post Office and Inland Revenue. Now destined to become a luxury hotel with a fine view of the river and city beyond.

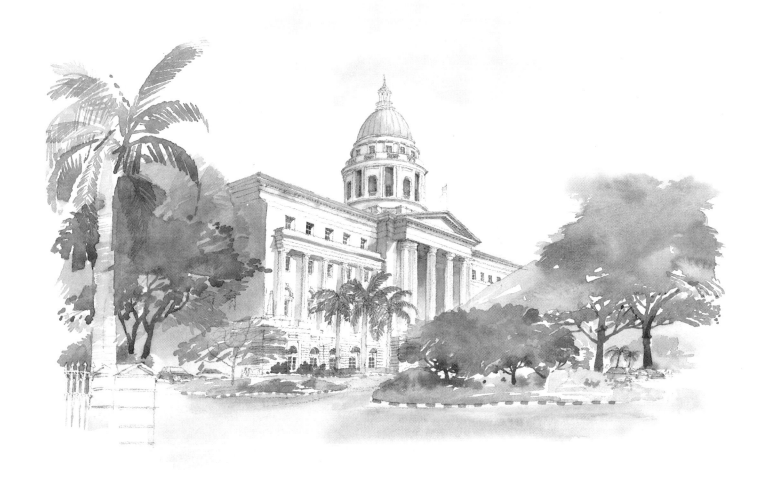

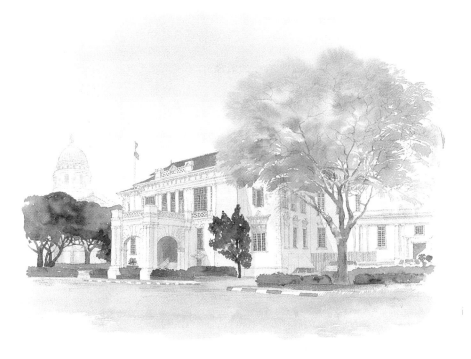

The Supreme Court, an imposing presence along St Andrew's Road was built in the late 1930s with sculptures executed by Italian artist Cav. R. Nolli. Although the Singapore Cricket Club (left) was officially founded in 1852, evidence suggests that cricket was played on the Padang even earlier. The central portion of the Victorian clubhouse dates from the 1880s with further additions in the 1920s.

The Museum precinct includes the Singapore Art Museum
(below) housed in the former St Joseph's Institution,
a Catholic boys school and the Asian
Civilisations Museum (right) in the former premises
of the well known Chinese Tao Nan School.
The National Museum (opposite page) opened
in 1887 as a museum of natural history and was
known as Raffles library and Museum.

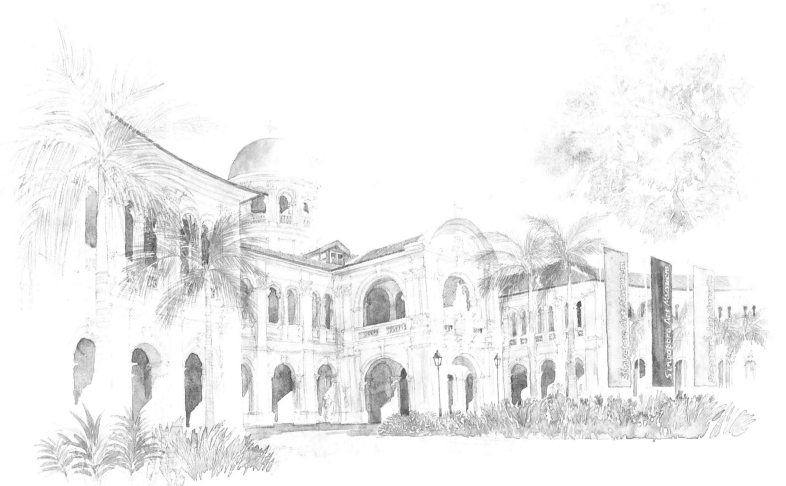

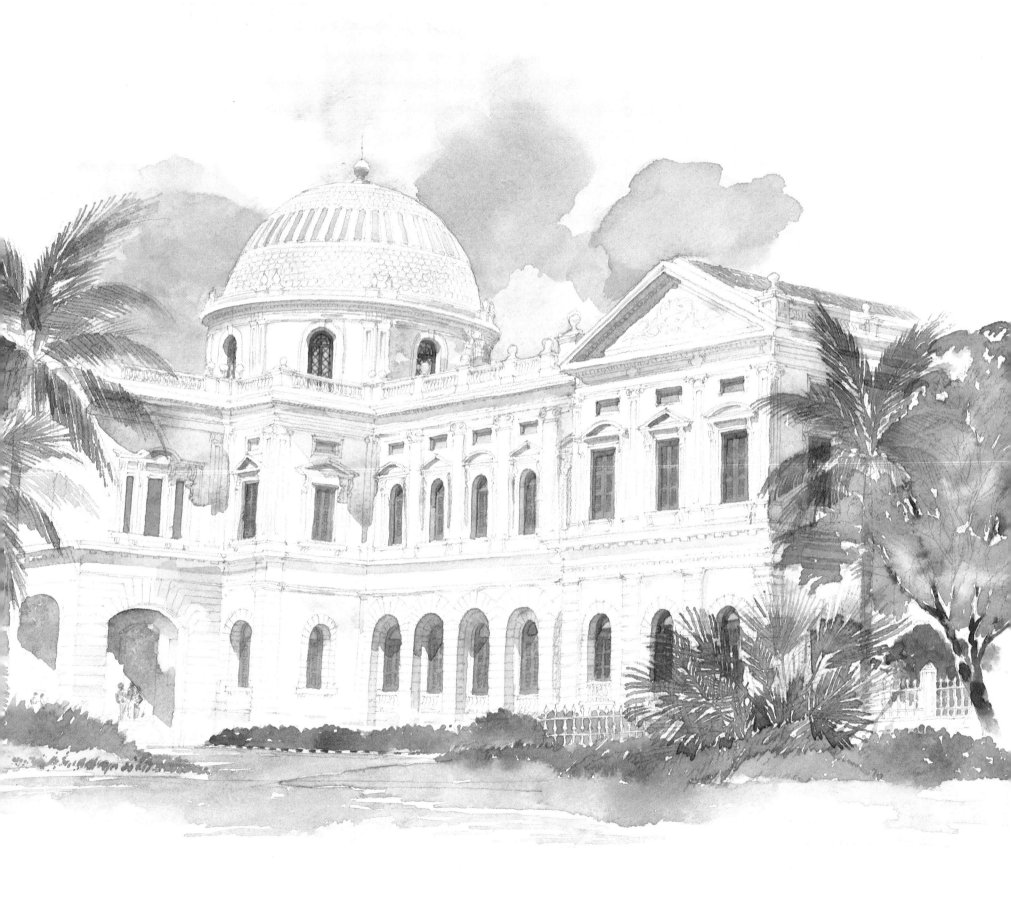

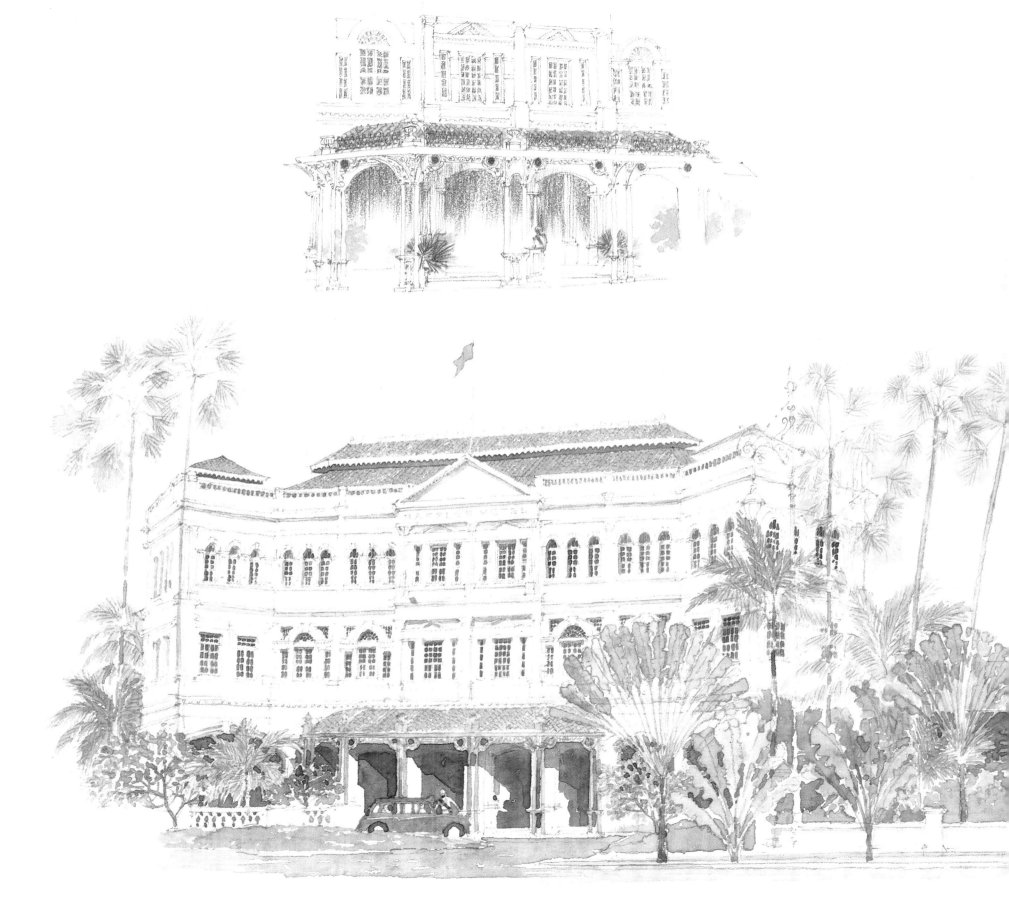

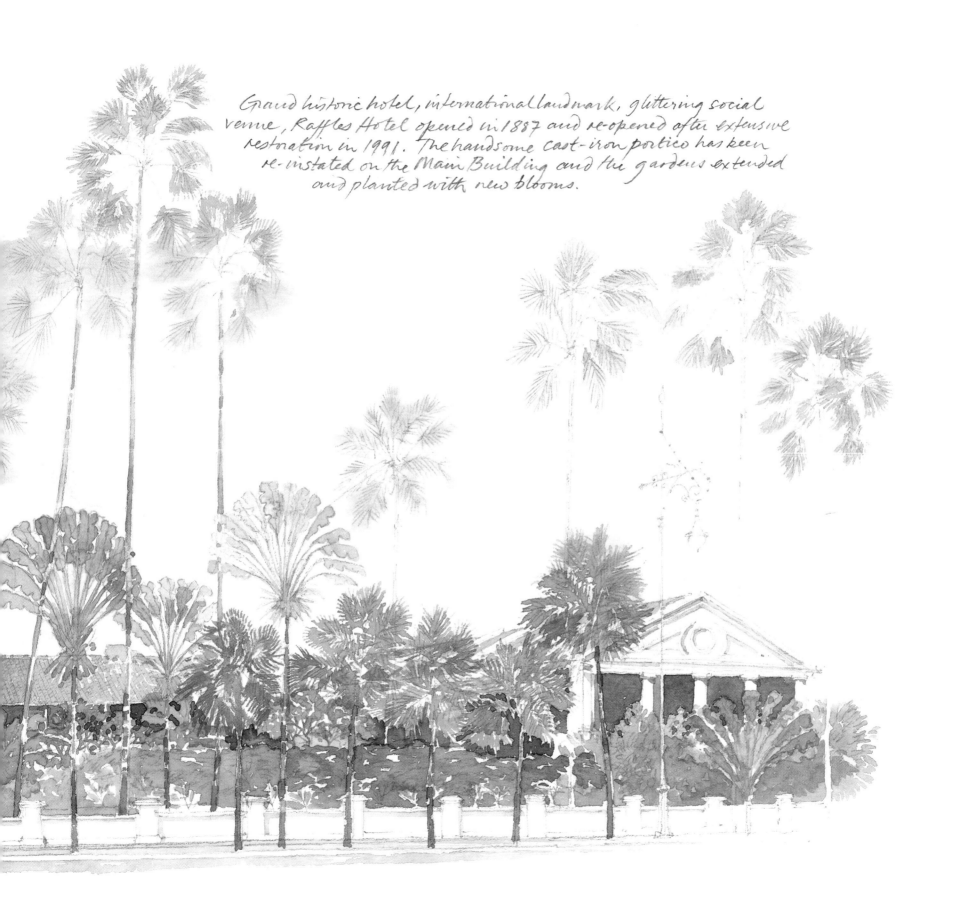

Grand historic hotel, international landmark, glittering social
venue, Raffles Hotel opened in 1887 and re-opened after extensive
restoration in 1991. The handsome cast-iron portico has been
re-instated on the Main Building and the gardens extended
and planted with new blooms.

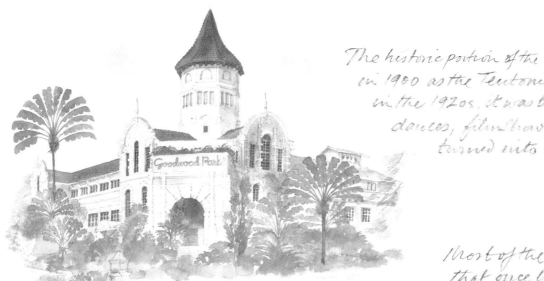

The historic portion of the Goodwood Park Hotel was built in 1900 as the Teutonia Club. Renamed Goodwood Hall in the 1920s, it was briefly used as a venue for concerts, dances, film shows and receptions until it was turned into a hotel in 1929.

Most of the small-scale commercial buildings that once lined fashionable Orchard Road have given way to steel-and-glass shopping centres. This row of colourfully restored structures is an exception.

The MPH Building has been a familiar sight along Stamford Road since 1908 when it was built as the headquarters of the Methodist Publishing House.

Opened in 1914 Stamford House was
briefly an annex of Raffles Hotel
called Grosvenor Hotel in the 1920s.
After restoration it reopened as a

shopping centre in 1995, with its
handsome plasterwork, including
the pediment, and cast-iron details
all beautifully restored.

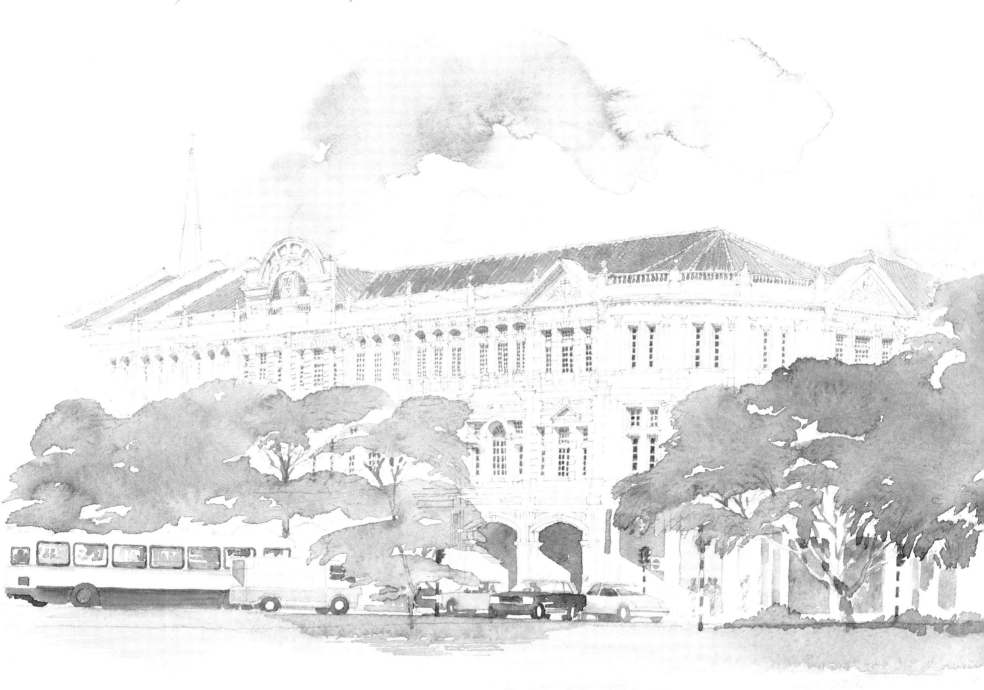

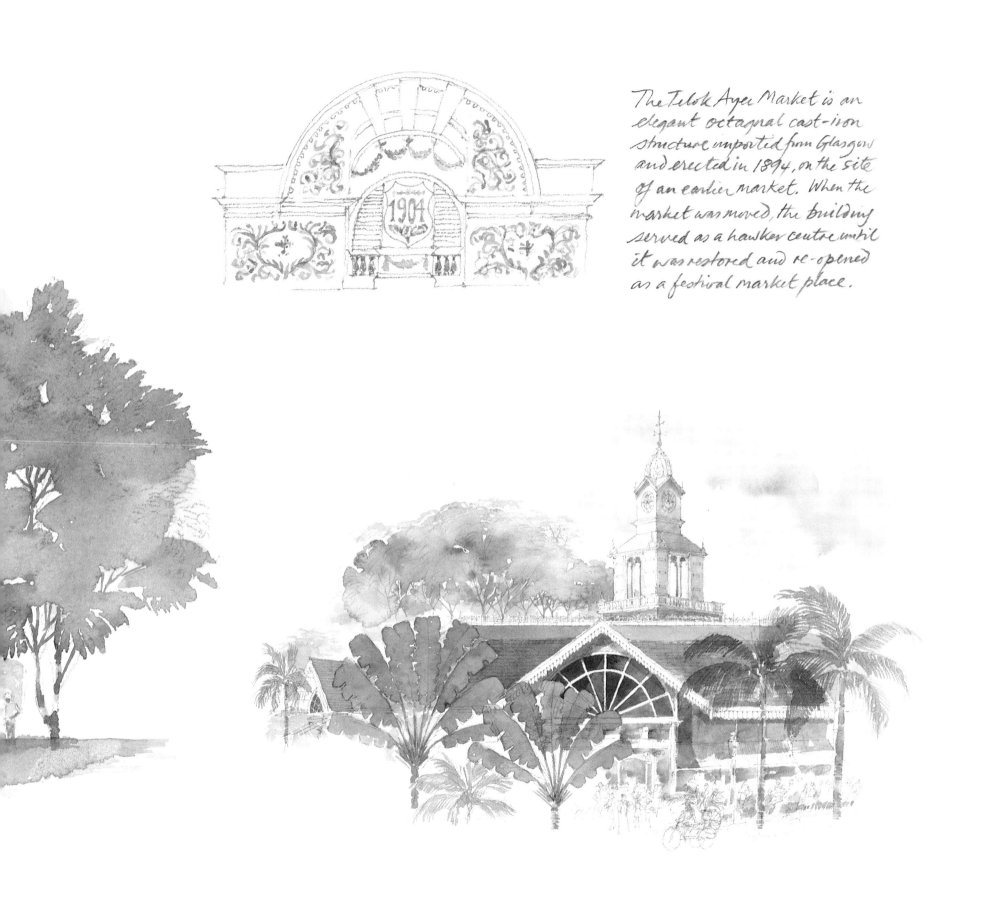

The Telok Ayer Market is an elegant octagnal cast-iron structure imported from Glasgow and erected in 1894, on the site of an earlier market. When the market was moved, the building served as a hawker centre until it was restored and re-opened as a festival market place.

Along the River

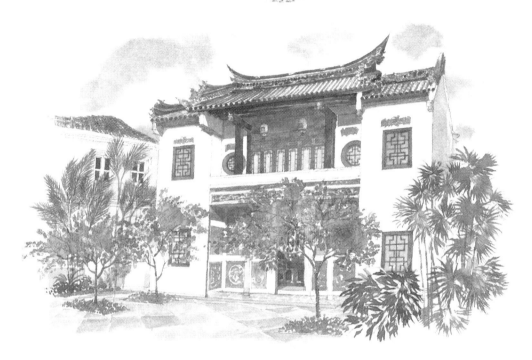

Clarke Quay's River House elegantly restored by skilled craftsmen in 1993 having served as a residence as well as a godown for gambier, biscuits and other commodities.

It was Singapore's free port status that set the pace for Boat Quay's rapid development. As soon as the swampy bank was filled with soil from the hillock shorn to create nearby Commercial Square (Raffles Place), European and Chinese merchants raised warehouses and offices with private jetties for loading and discharging cargo ferried upstream by small boats from all manner of seafaring craft arriving in the port. Further upstream, at Clarke Quay, development was less frenetic, more varied and occurred several decades later. Traders' godowns were interspersed with pineapple canning factories, engineering works like Riley & Hargreave and Whampoa's famous Ice House.

By the early 1980s, progress had nudged out the river's entrepôt trade. The boats that had for a century and a half jostled for space along the crowded quays — ferrying spices, coffee, tea, rice, rubber and tin from large ships beyond the river's mouth — were relocated to Pasir Panjang. A massive river clean-up project was launched and the historical buildings nestled along the river's edge were granted a reprieve.

When Boat Quay was gazetted a Conservation Area in 1989, developers were quick to realize its commercial potential. Today it is lined with art galleries, pubs and restaurants. Clarke Quay, also gazetted a Conservation Area in 1989, was redeveloped as a large Festival Village. Completed in 1993, it is Singapore's largest privately executed conservation project. The pioneering merchants would undoubtedly have approved the entrepreneurial spirit that has brought life back to the river, even though the type of economic activity is vastly different.

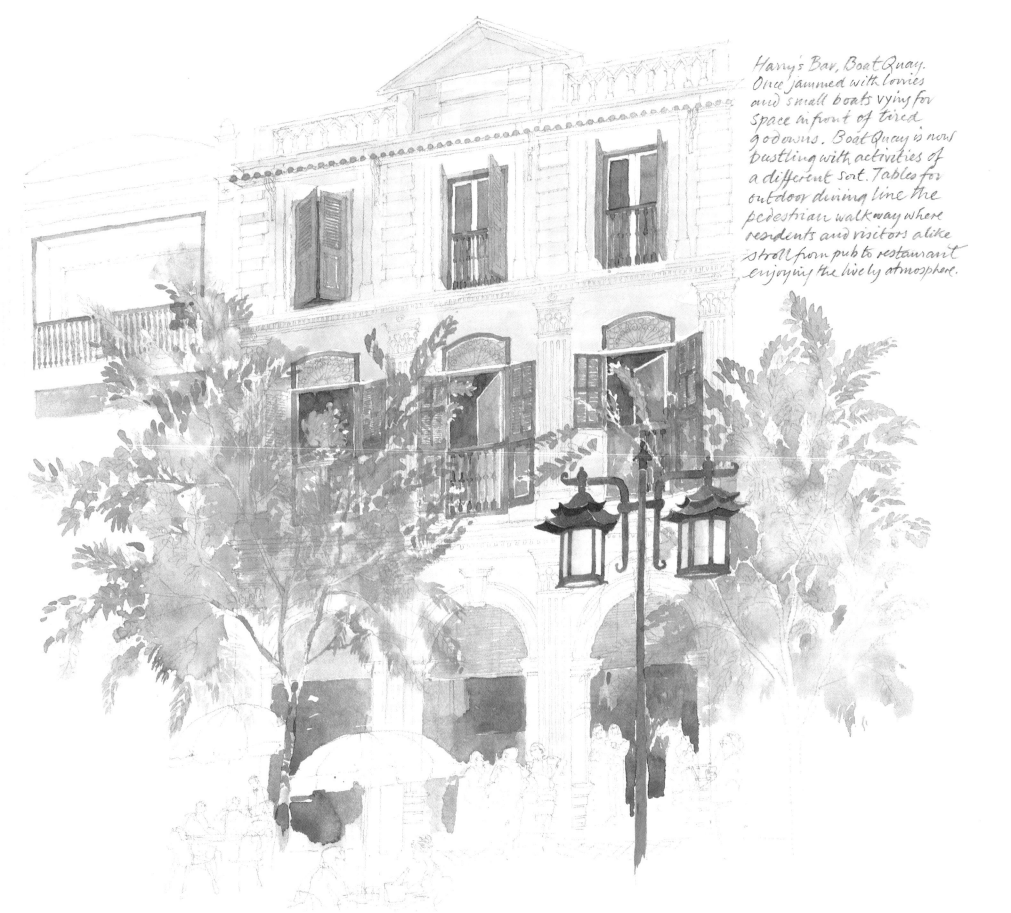

Harry's Bar, Boat Quay.
Once jammed with lorries
and small boats vying for
space in front of tired
godowns. Boat Quay is now
bustling with activities of
a different sort. Tables for
outdoor dining line the
pedestrian walkway where
residents and visitors alike
stroll from pub to restaurant
enjoying the lively atmosphere.

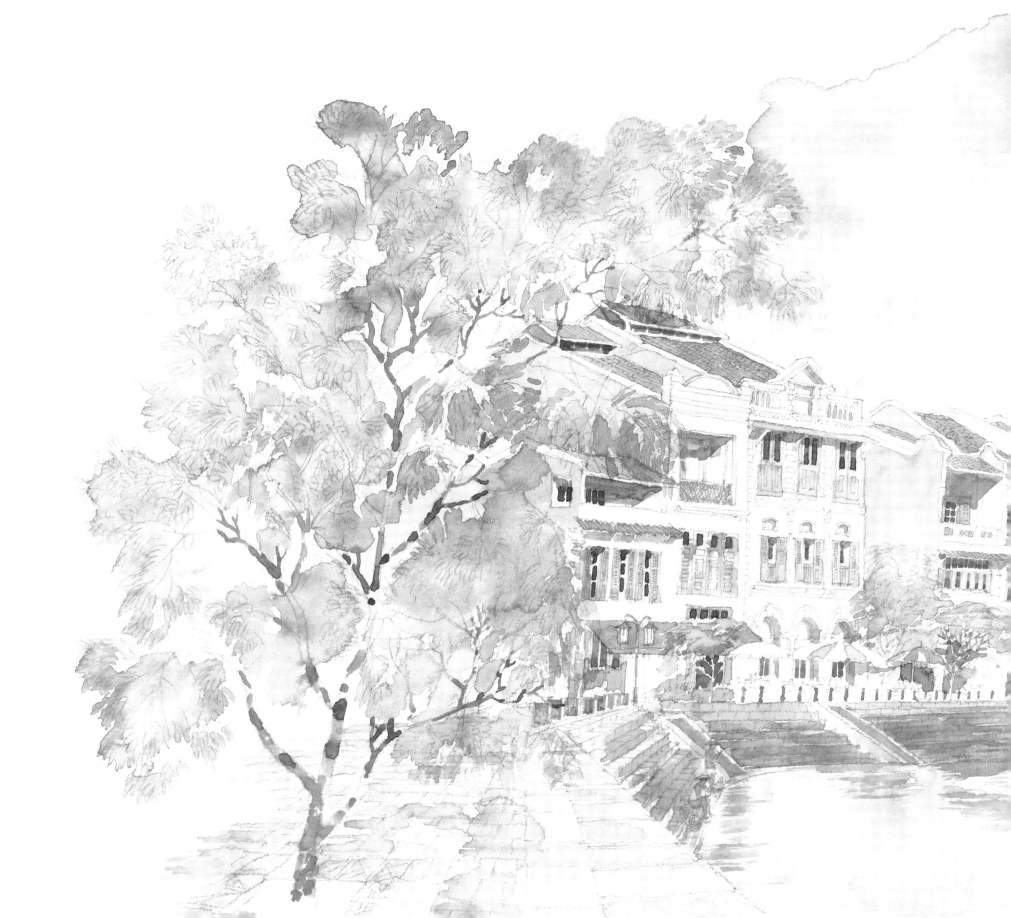

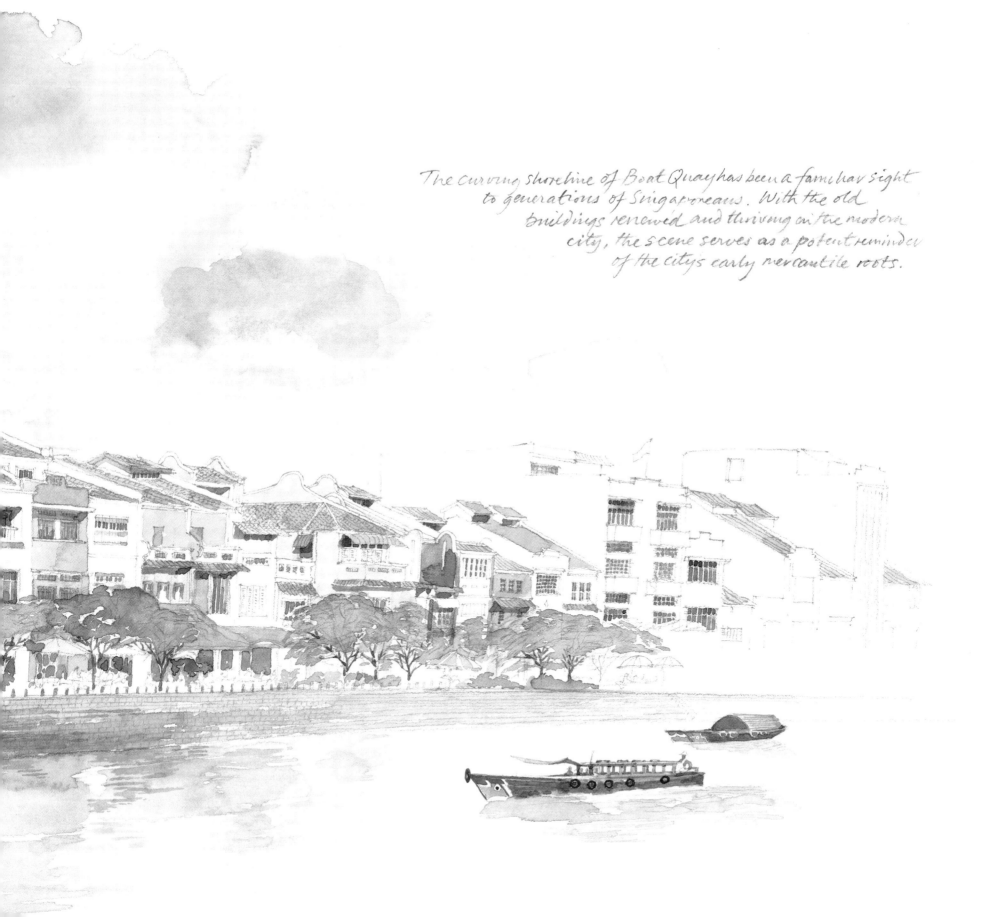

The curving shoreline of Boat Quay has been a familiar sight to generations of Singaporeans. With the old buildings renewed and thriving in the modern city, the scene serves as a potent reminder of the city's early mercantile roots.

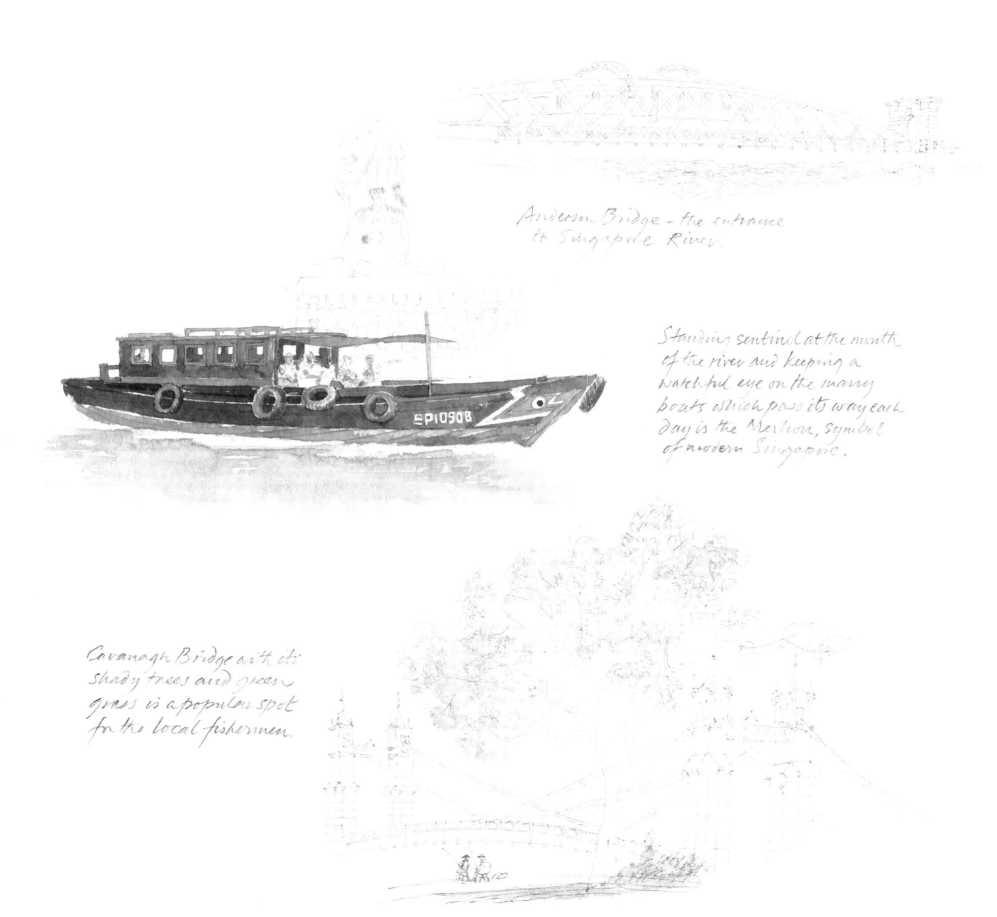

Anderson Bridge - the entrance
to Singapore River.

Standing sentinel at the mouth
of the river and keeping a
watchful eye on the many
boats which pass its way each
day is the Merlion, symbol
of modern Singapore.

SP1090B

Cavanagh Bridge with its
shady trees and green
grass is a popular spot
for the local fishermen.

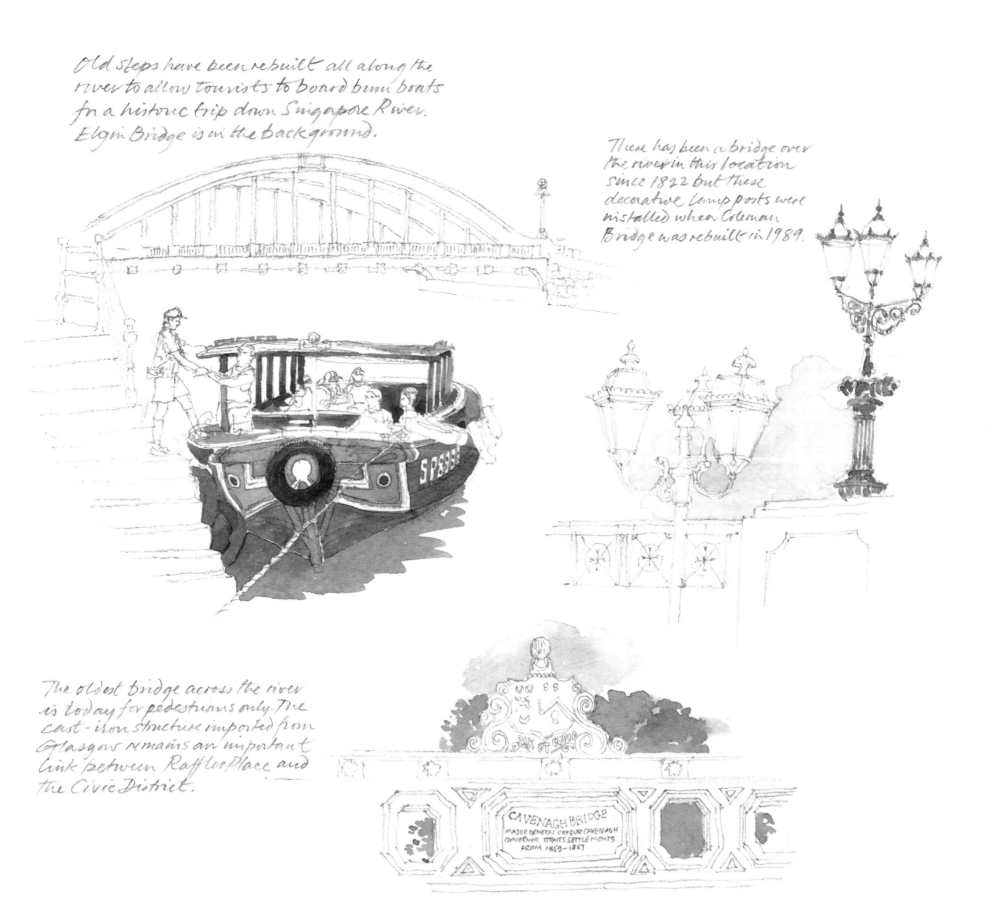

Old steps have been rebuilt all along the
river to allow tourists to board bum boats
for a historic trip down Singapore River.
Elgin Bridge is in the background.

There has been a bridge over
the river in this location
since 1822 but these
decorative lamp posts were
installed when Coleman
Bridge was rebuilt in 1989.

The oldest bridge across the river
is today for pedestrians only. The
cast-iron structure imported from
Glasgow remains an important
link between Raffles Place and
the Civic District.

CAVENAGH BRIDGE

MAJOR GENERAL ORFEUR CAVENAGH
GOVERNOR STRAITS SETTLEMENTS
FROM 1859-1867

A trio of restored
buildings in Clarke
Quay's Merchant
Court block includes
an exquisite
Chinese mansion
and J.P. Bastiani's
restaurant.

Clarke Quay. Here coolie labourers once broke
their backs or made fantastic fortunes. Progress
has nudged the godowns and rivercraft
to other localities but the humble and hardworking
historical buildings nestled along the river's edge
have been carefully restored and brought back
to life as a festival village.

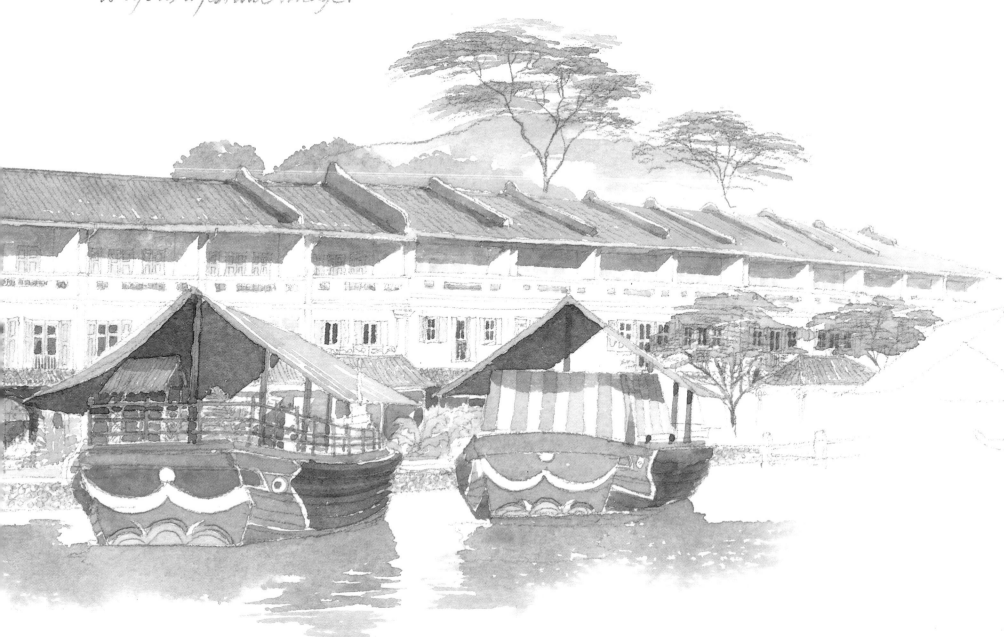

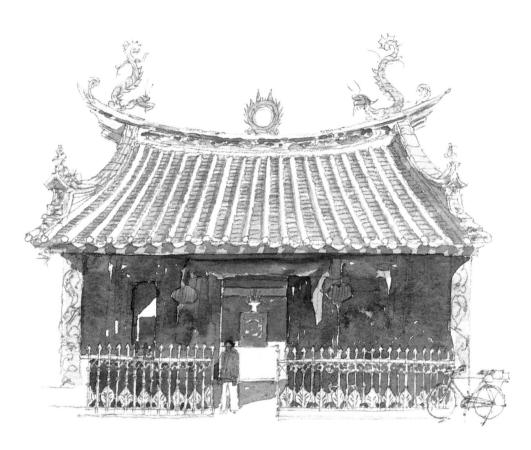

Thian Hock Keng.
Singapore's oldest Chinese temple
may no longer hug the seashore
but it remains much the same
as it was when wealthy Hokkien
merchants gathered in the early
1840s to celebrate its completion.

The concept of a 'Chinatown' originated with Sir Stamford Raffles. Anticipating that the Chinese would eventually form the largest segment of the population, he allocated the entire area south of the Singapore River beyond Boat Quay and Commercial Square for their kampong. Today, Chinatown is Singapore's largest Conservation District, with 1,200 conservation buildings on 23 hectares (57 acres) in four subdistricts — Telok Ayer, Kreta Ayer, Bukit Pasoh and Tanjong Pagar.

Telok Ayer was the original Chinatown, developing from the 1820s onwards. The earliest shophouses showed southern Fujian influence in the roofs and gable walls. Telok Ayer Street once faced the sea and it was here in 1821 that the Hokkiens founded a small temple on the site of the present Thian Hock Keng.

Kreta Ayer was already urbanized by the 1860s and remained chronically overcrowded well into the 20th century. Behind the neat, elegant façades of the shophouses were coolie quarters and intensively subdivided properties offering little more than a cubicle as living accommodation.

Tanjong Pagar's early development was intimately associated with the burgeoning port facilities in the nearby harbour area from the 1870s onwards, while it was in Bukit Pasoh from the 1880s that many of Chinatown's key cultural, educational and institutional associations were established.

Even today, Chinatown's landscape is dominated by two- and three-storey shophouses that range from the most basic and utilitarian to the lavishly decorated examples of the style that some have dubbed 'Straits Chinese' or 'Chinese Eclectic'.

MOSQUE STREET 0105

TELOK AYER

AMOY STREET
TEMPLE

康

PAGODA STREET

WONG ON TAILOR

黄耀南藥行

荣美百貨商店

ALTERATIONS
TO SHOP
OPEN
FOR
BUSINESS

圖強洋服

洋服

Impressions of Chinatown. A montage of shuttered windows, street signs, street life, scaffolding and a sleepy trishaw driver.

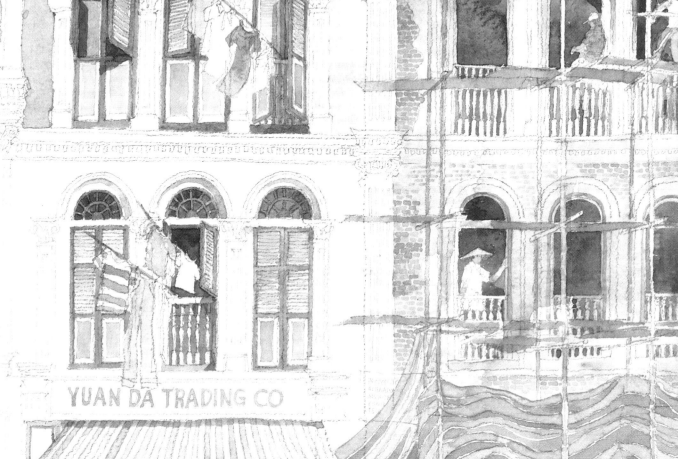

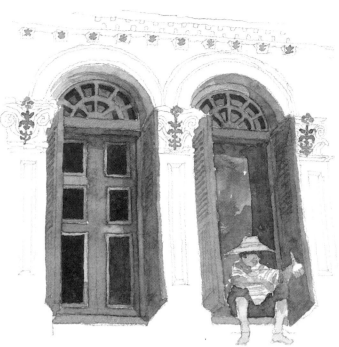

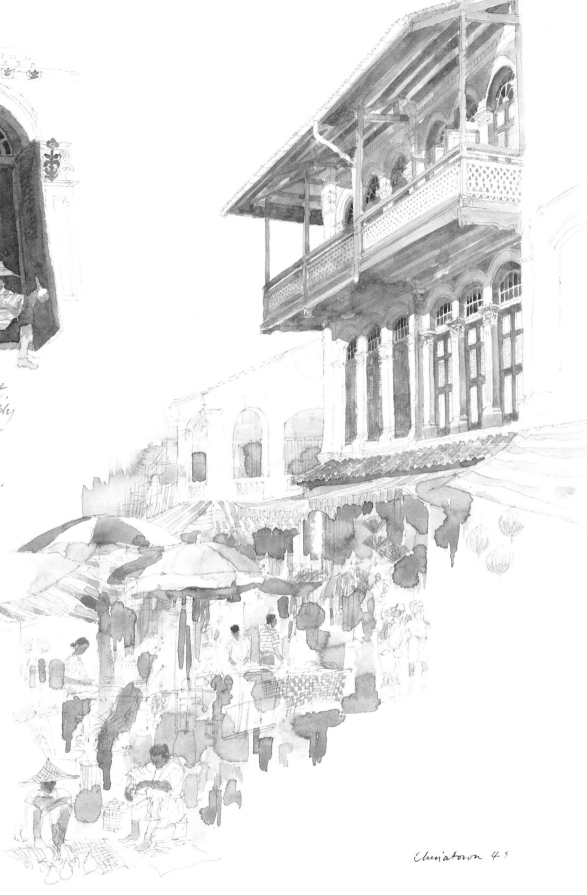

Change comes to Pagoda Street.
Chinatown's shophouses, so humbly
and strenuously used, exhibit a
sense of proportion and
refinement of architectural
detail timeless in their appeal.
Once cramped and overcrowded
coolie lodging houses, Pagoda
Streets' shophouses are being
restored and given new life.
(Left)

Trengganu Street is often
thought of as the heart of
Chinatown. This
shophouse at No 15-17
adjoins the Lai Chun Yoen
theatre and, now restored,
provides a dramatic
backdrop to modern
Chinatown streetlife.
(right)

Chinatown 45

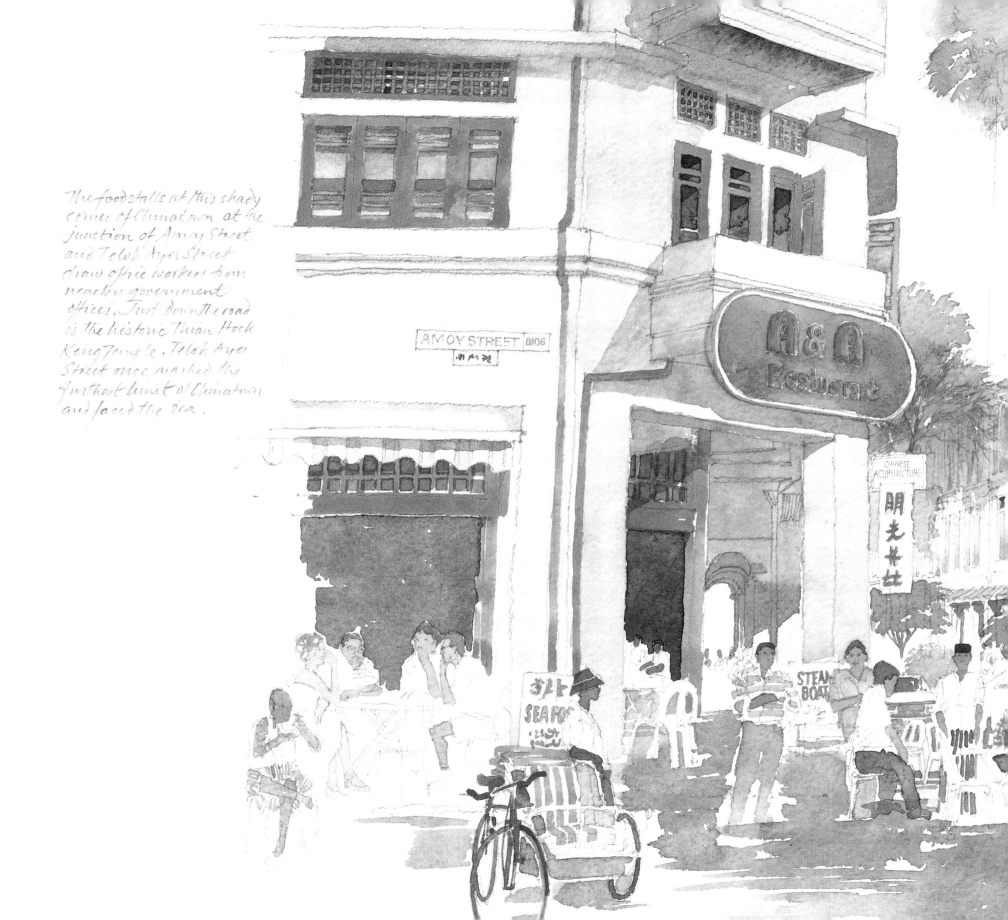

The foodstalls at this shady
corner of Chinatown at the
junction of Amoy Street
and Telok Ayer Street
draw office workers from
nearby government
offices. Just down the road
is the historic Thian Hock
Keng Temple. Telok Ayer
Street once marked the
furthest limit of Chinatown
and faced the sea.

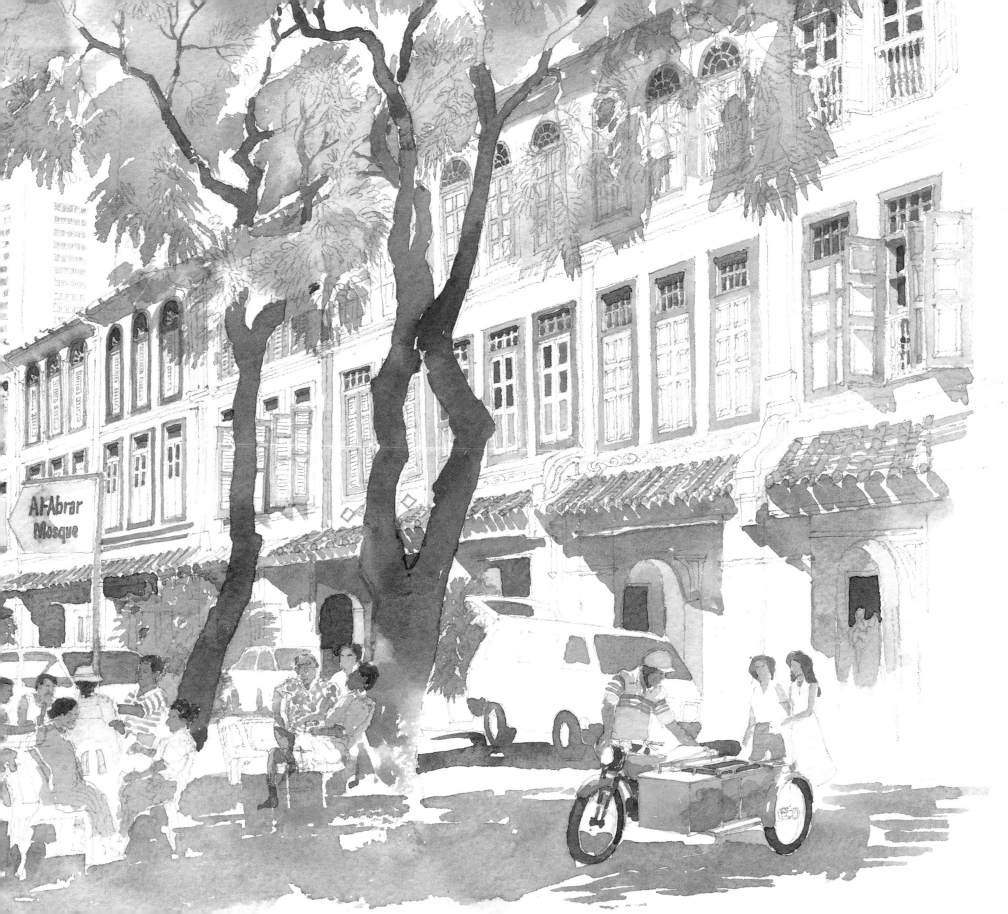

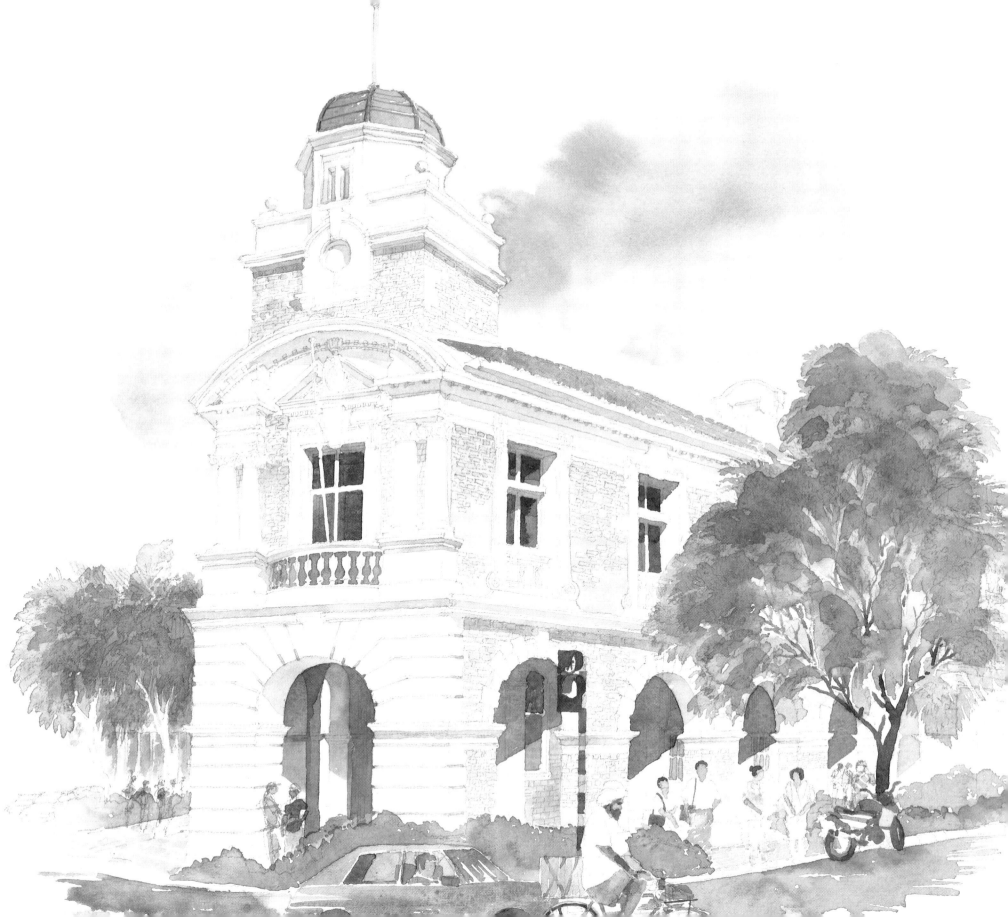

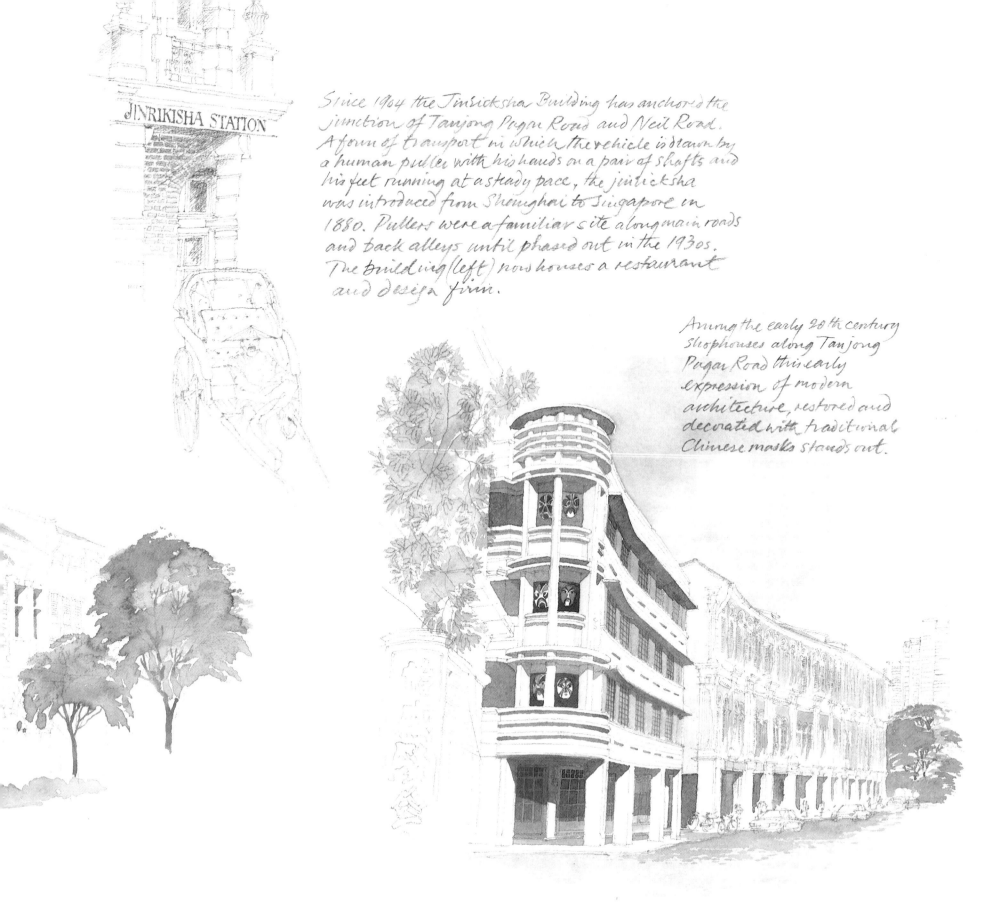

JINRIKISHA STATION

Since 1904 the Jinricksha Building has anchored the junction of Tanjong Pagar Road and Neil Road. A form of transport in which the vehicle is drawn by a human puller with his hands on a pair of shafts and his feet running at a steady pace, the jinricksha was introduced from Shanghai to Singapore in 1880. Pullers were a familiar site along main roads and back alleys until phased out in the 1930s. The building (left) now houses a restaurant and design firm.

Among the early 20th century shophouses along Tanjong Pagar Road this early expression of modern architecture, restored and decorated with traditional Chinese masks stands out.

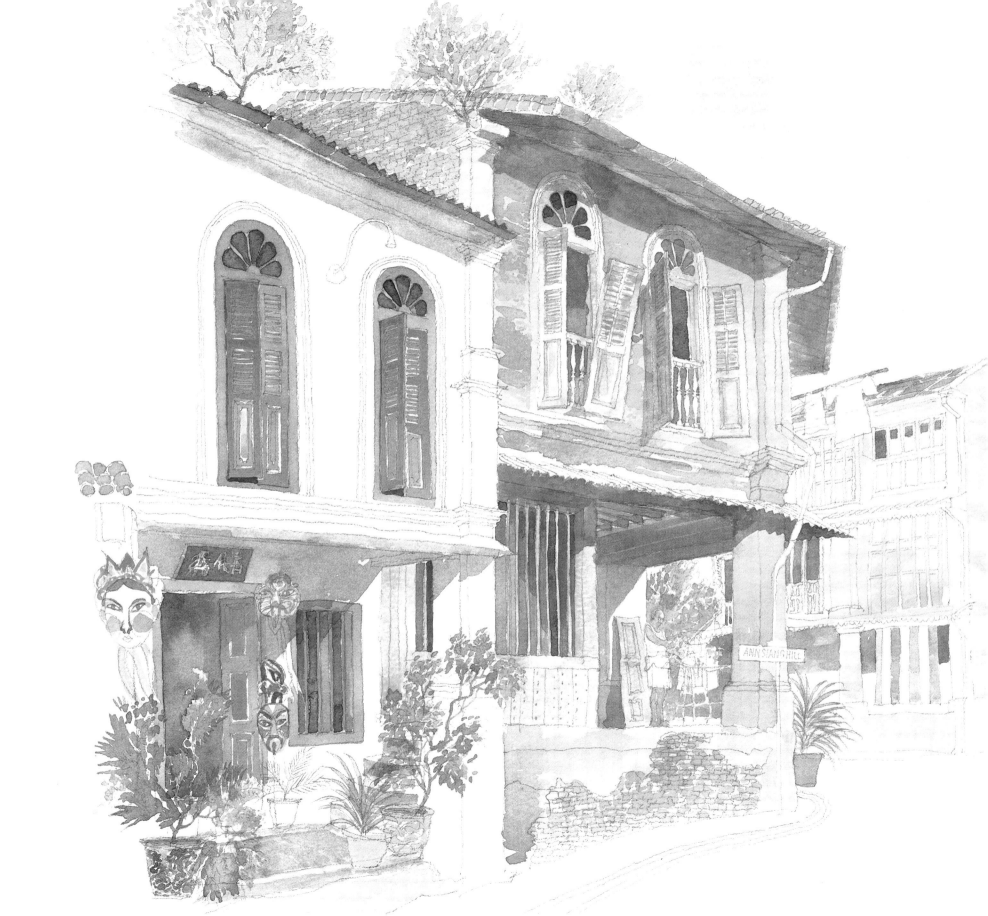

Ann Siang Hill and Club Street in transition. This area of Chinatown contains a lively mixture of shophouse styles all linked together by the ubiquitous five foot way. Once a popular location for Chinese clan associations Ann Siang Hill is now a sought-after address for design, advertising and architectural firms, art galleries and small hotels. The mask maker and the Chinese laundry (left) are among the oldtimers who keep up their businesses on the hill.

CLAN ASSOCIATION

Decorative façades at Bukit Pasoh. This grouping of 1930s shophouses exhibits shophouse architecture at its most flamboyant, with elegant plasterwork, lacey cast-iron balustrades, canti-levered balconies and carved timber fascia boards.

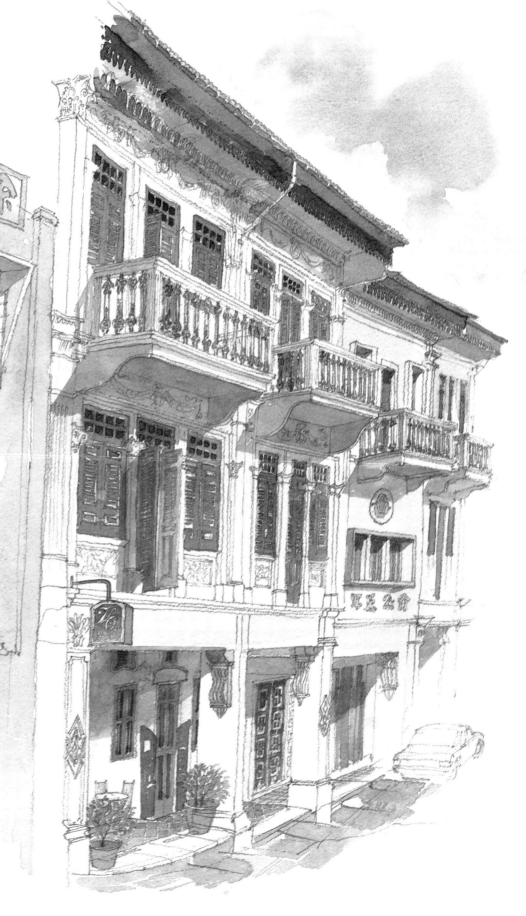

At the turn of the century, prospering
Chinese merchants inhabited these
handsome shophouses in Duxton Hill.
As the merchants moved onto more
salubrious suburbs, the buildings
were often divided into tiny
cubicles which served as homes
to the Chinese immigrants who
made their way to Singapore's
shores in search of a better life.

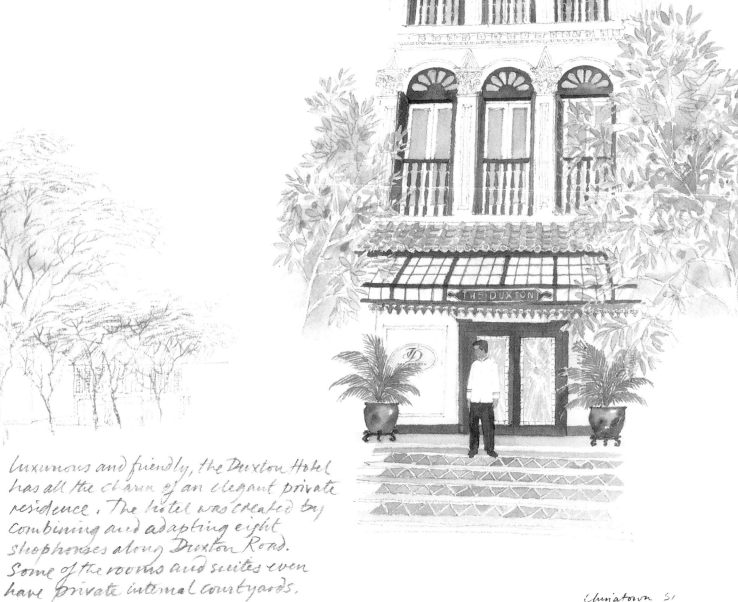

Luxurious and friendly, the Duxton Hotel
has all the charm of an elegant private
residence. The hotel was created by
combining and adapting eight
shophouses along Duxton Road.
Some of the rooms and suites even
have private internal courtyards.

Chinatown 51

Kampong Glam

*Masjid Sultan
has dominated Kampong
Glam since the
mid 1920s. It remains
an important focal
point for Muslims
from all over the
island.*

Kampong Glam has held fast to a sense of community and tradition amidst a rapidly changing urban landscape.

A fishing village at the mouth of the Rochor River at the time of Raffles' landing in 1819, it derived its name from the Gelam tree which grew in abundance in the area and produced a bark for caulking boats. By the terms of the 1823 Town Plan, the area was reserved for the Muslim community. A large tract of land therein was granted to Sultan Hussein Shah, who had signed the treaty allowing the British to set up a factory on the island. Here he built his palace. Adjacent land was set aside for a mosque and burial ground.

The rapid influx of Muslim immigrants in the late 19th century gave rise to several small kampongs such as Kampong Malacca, Kampong Java and Kampong Bugis. The influence of the numerically small but important Arab community was acknowledged when street names were allocated early in the 20th century — Arab Street, Bussorah Street, Muscat Street and Baghdad Street.

In the 1920s, Kampong Glam became increasingly urbanized. Commercial activities expanded, new shophouses were constructed, and the wealthy Arab families moved to the suburbs. As a result of the competition for land, the Malay population was relocated *en masse* to designated resettlement areas in Geylang Serai and Kampong Eunos.

The Kampong Glam Conservation District, gazetted in 1989, covers a land area of nearly nine hectares (22 acres) and contains 620 conservation buildings.

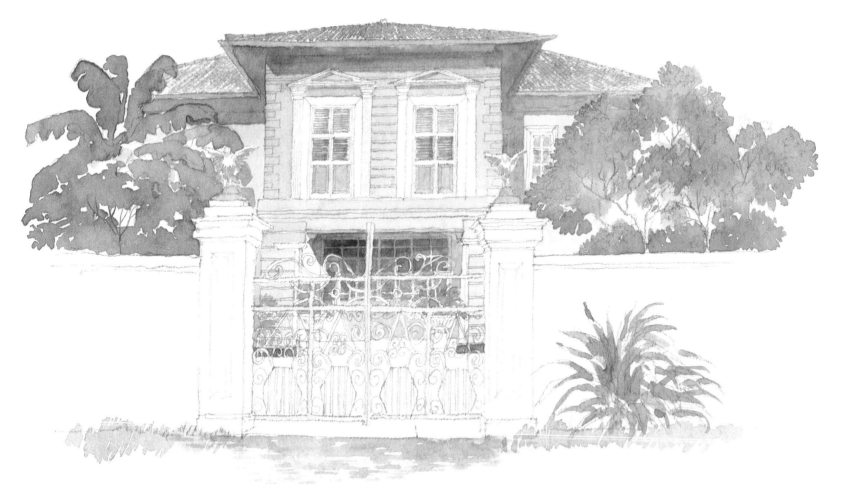

No 73 Sultan Gate (above) is a
handsome Palladian-inspired
house that was built in the
1920s for Haji Yusof.

The Istana Kampong Glam (right)
was built in the 1840s as the home
of Sultan Hussein who signed the
treaty that granted Sir Stamford
Raffles the right to set up a
port in Singapore. Plans
have been proposed to turn
it into a heritage park.

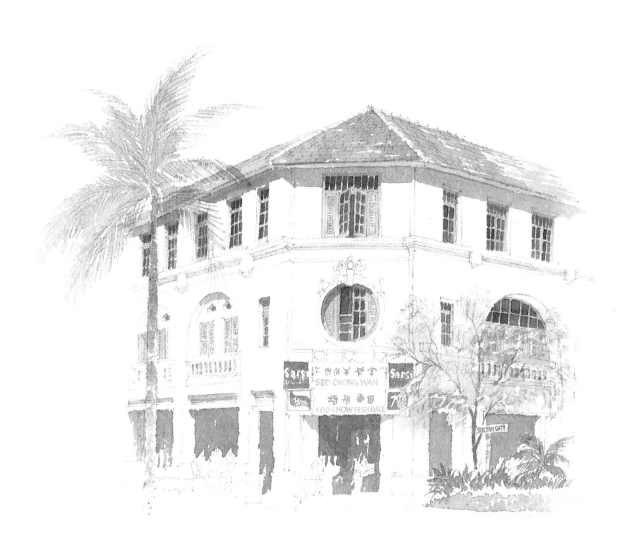

A more 'modern' version of shophouse architecture at the corner of Sultan Gate and Beach Road. Beach Road once faced the beach, but the first land reclamation was undertaken several decades before this building was constructed.

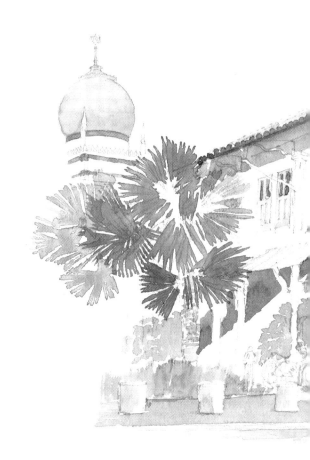

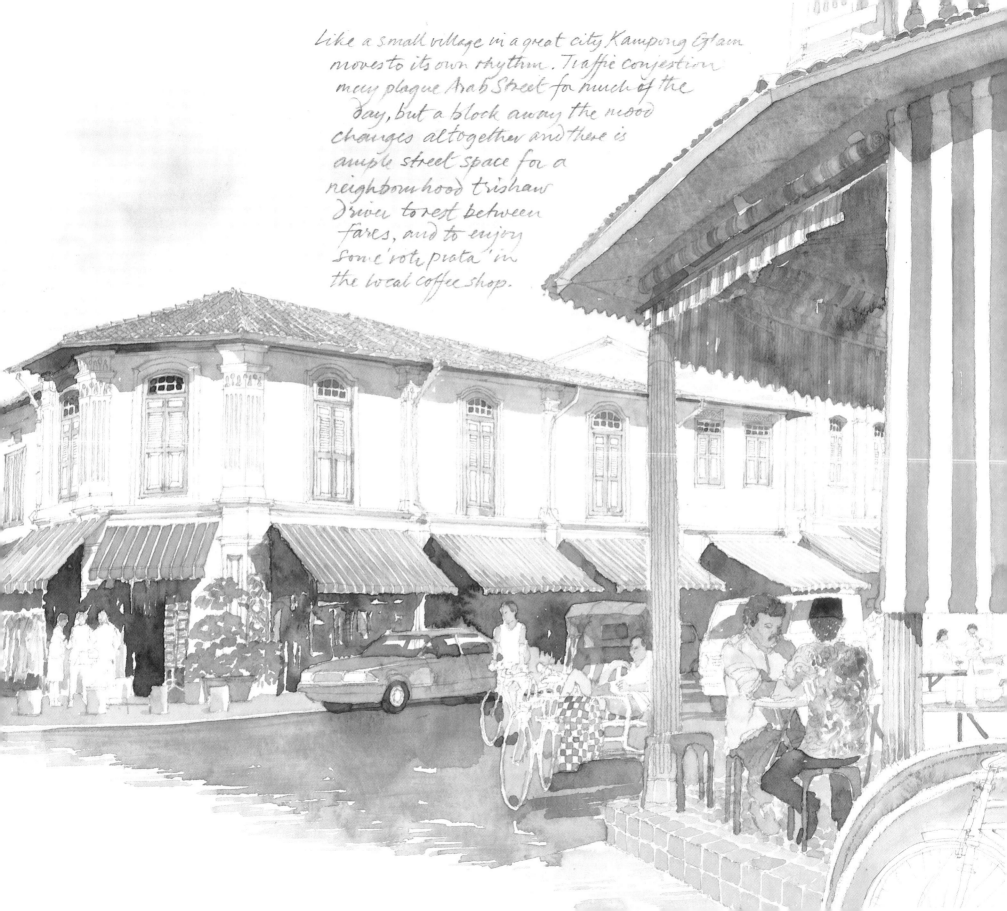

Like a small village in a great city Kampong Glam
moves to its own rhythm. Traffic congestion
may plague Arab Street for much of the
day, but a block away the mood
changes altogether and there is
ample street space for a
neighbourhood trishaw
driver to rest between
fares, and to enjoy
some 'roti prata' in
the local coffee shop.

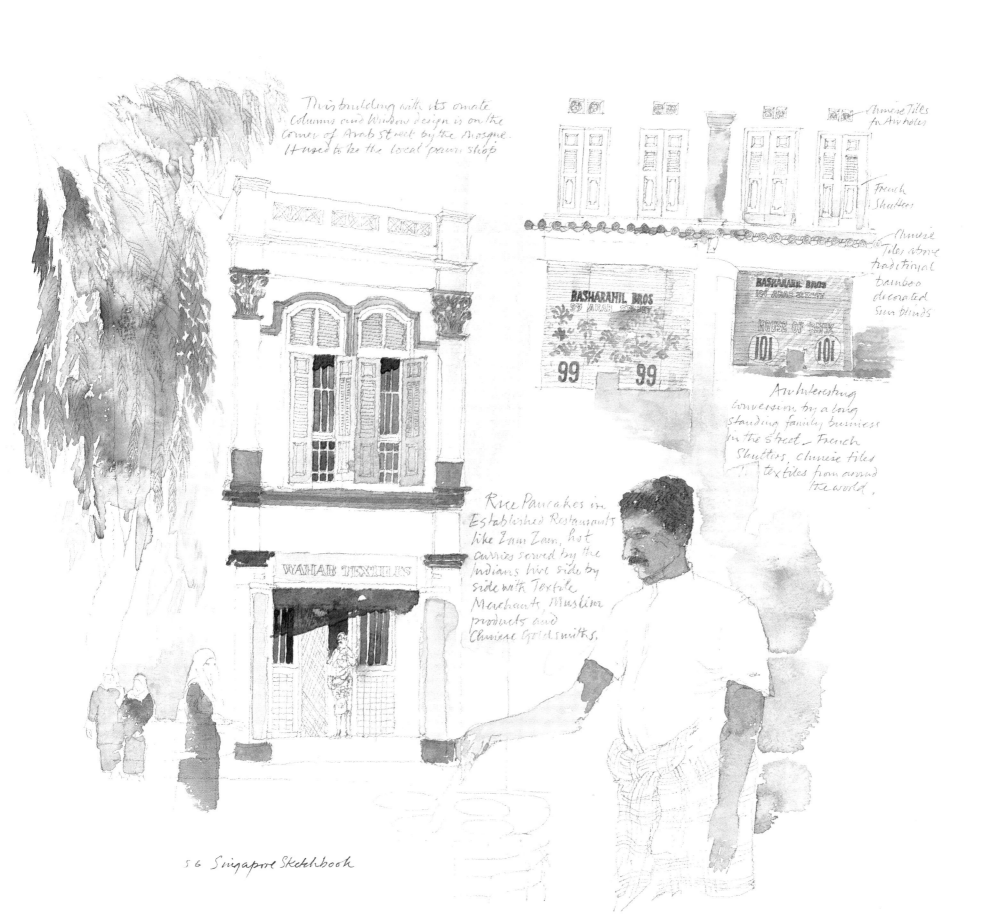

This building with its ornate
columns and window design is on the
corner of Arab Street by the mosque.
It used to be the local pawn shop

Chinese Tiles
for Airholes

French
Shutters

Chinese
Tiles above
traditional
bamboo
decorated
Sun blinds

BASHARAHIL BROS
99 ARAB STREET

BASHARAHIL BROS
101 ARAB STREET

99 99

HOUSE OF BATIK
101 101

An interesting
conversion by a long
standing family business
in the street — French
Shutters, Chinese tiles
textiles from around
the world.

Rice Pancakes in
Established Restaurants
like Zam Zam, hot
curries served by the
Indians live side by
side with Textile
Merchants, Muslim
products and
Chinese Goldsmiths.

WAHAB TEXTILES

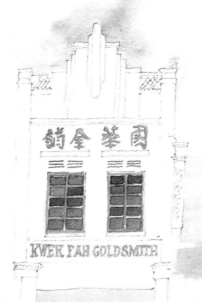

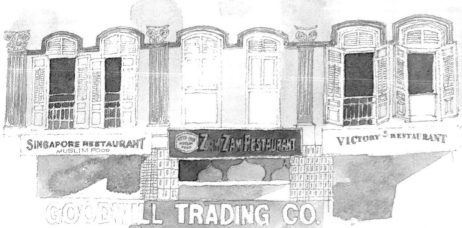

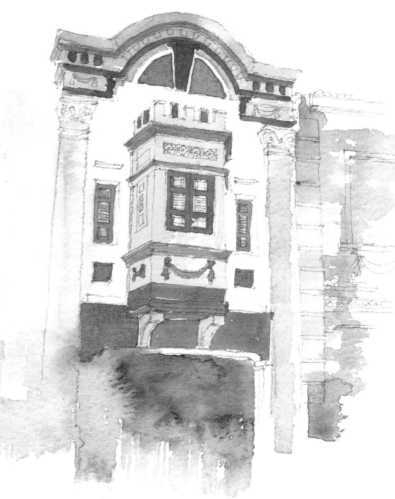

Old signs with a
fresh look are showing
off their trades alongside
restored buildings.

Amazing colours are appearing
in Kampong Glam, with houses
suddenly coming alive again,
not only with paint but with
new businesses opening up on
every street, together with the
old established names.

Kampong Glam 57

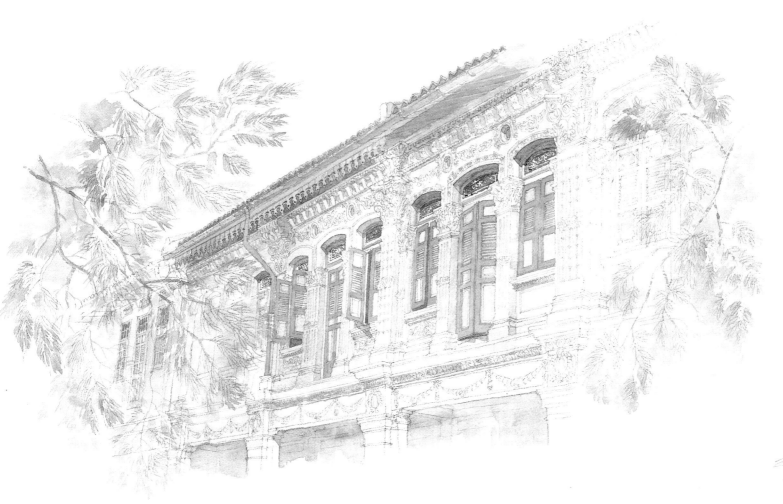

Picturesque unrestored basket shops at the
corner of Arab Street and Beach Road (right)
are considered as one of the most attractive
sights in Kampong Glam, as is the
particularly handsome row of six
terrace houses lavished with
imaginative decorative plasterwork
along nearby Kandahar Street (above).

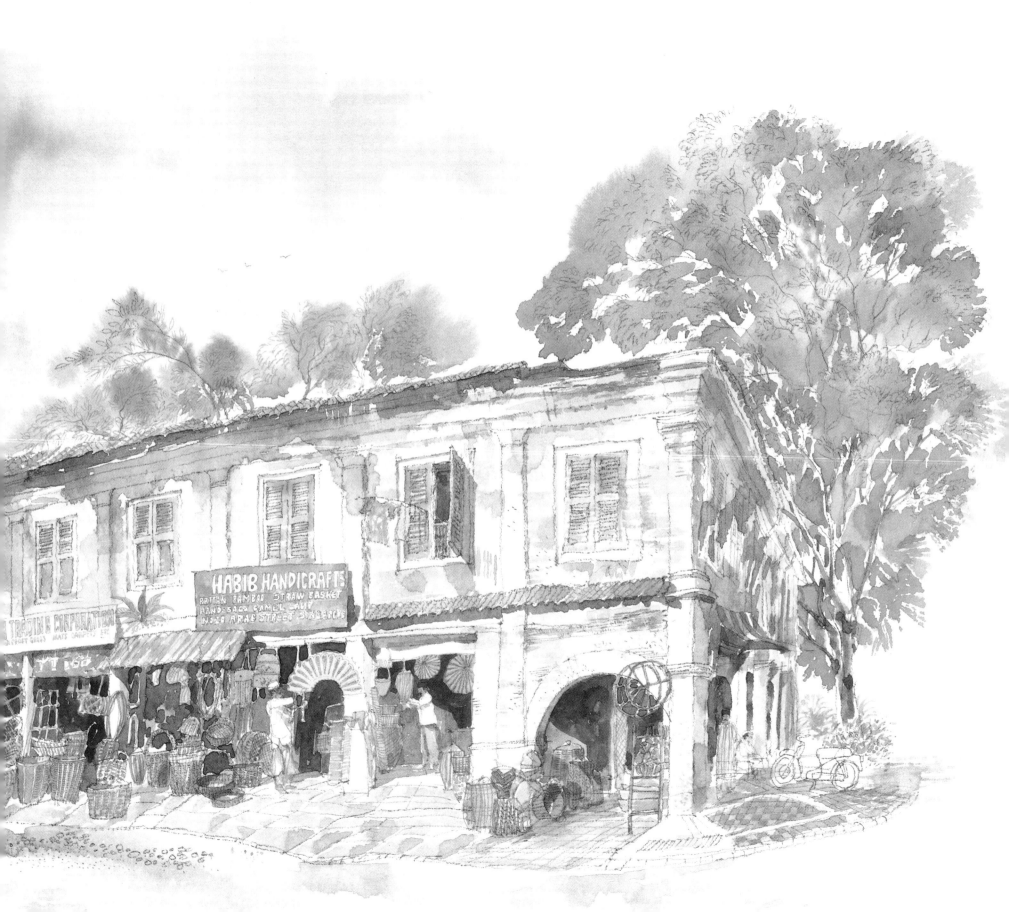

Little India was once aptly described by a local restaurant proprietor as an 'every-kind-of-people-coming-place'; and so it is. Unlike Chinatown and Kampong Glam, where colonial politics and Raffles' sense of order prevailed to determine ethnic character, Little India evolved as an integral part of Singapore's urban fabric, a kind of mini Madras.

Initially the land was attractive to South Indians engaged in cattle-related activities because of the abundance of water and grass in the area. Though not densely populated for much of the 19th century, the environs eventually embraced both the residences of the higher echelons of colonial society as well as the livelihood of the lower. The racecourse and bungalows of European and Eurasian civil servants co-existed with vegetable gardens, cattle pens and slaughterhouses. Eventually the bungalows and their tidy compounds made way for building types more suitable for the commercial character of the area. By the time cattle were banned from the municipality in 1936, the face of Little India was much as we know it today.

At the heart of Little India is Serangoon Road, and here South Indian commercial settlers congregated until it became one of the four areas strongly associated with Singapore's multifaceted Indian community — along with the areas of High Street, Market Street and Chulia Street, and Tanjong Pagar and Keppel Road.

Given official conservation status in 1989, the Little India Conservation District covers an area of nearly 13 hectares (32 acres) and has a total of 900 conservation buildings.

Along Kerbau Road in the heart of Little India's Conservation District stands this classic example of Straits Chinese architecture.

In a timeless scene, trishaw drivers wait patiently for customers in front of restored Buffalo Road shophouses for shoppers from Zhujiao market laden with foodstuffs.

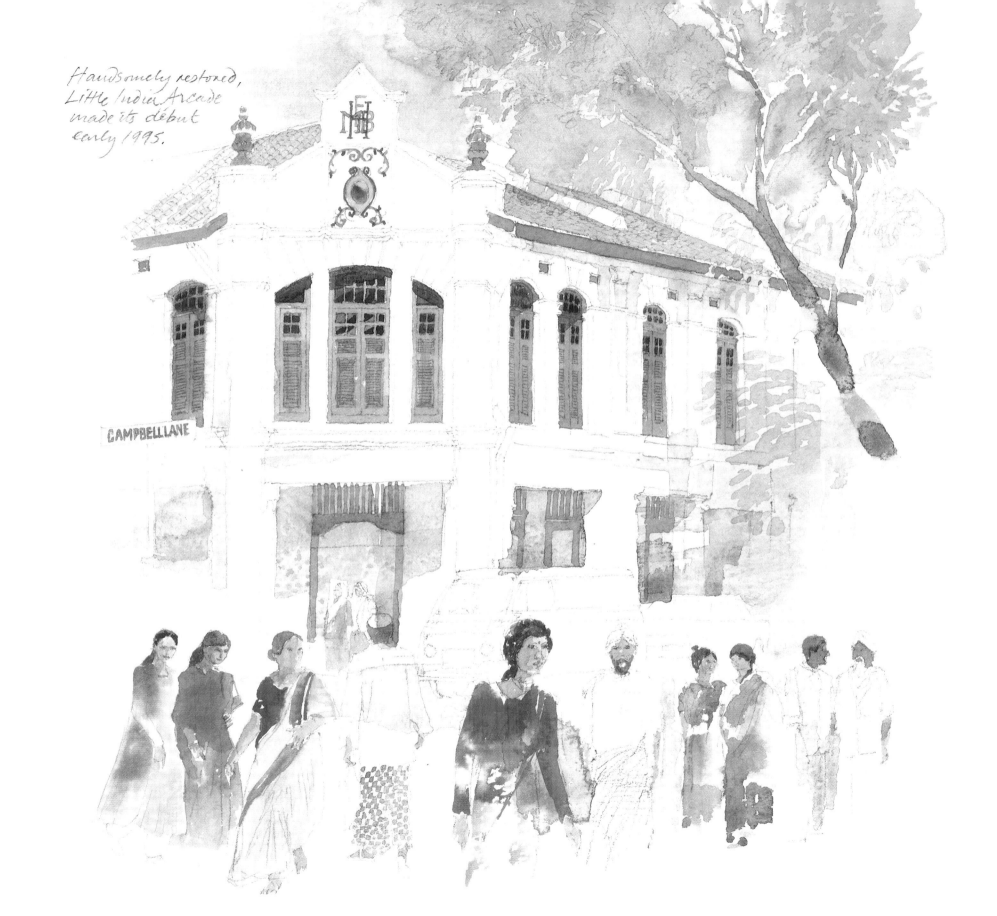

Handsomely restored,
Little India Arcade
made its debut
early 1995.

CAMPBELL LANE

Many traditional Indian trades have returned to Little India's restored shophouses, bringing back the assemblage of colours, aromas and sounds that are distinctly Little India.

SERANGOON ROAD

Sri Srinivasa Perumal Temple is one of Little India's best-known landmarks.

In Kerbau Road, a recently built hawker stall with Indian-style roof shares space with beautifully restored ornate terrace houses.

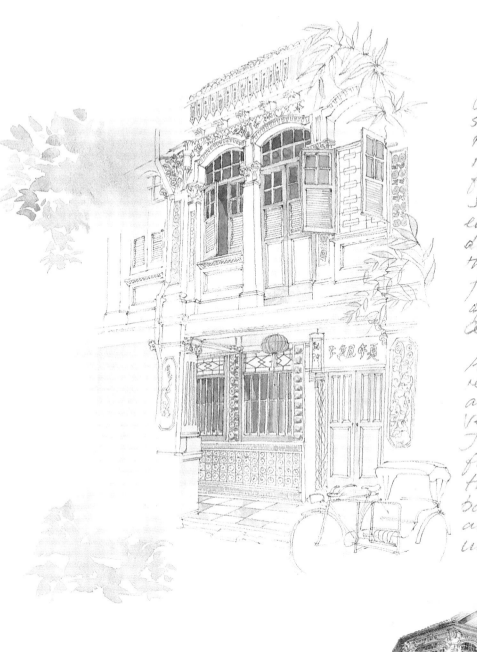

One of the eighteen striking shophouses along Petain Road (left). Widely regarded as among the finest examples of Singapore's richly ornate early 20th century domestic architecture, they are much admired for the lavish display of glazed green and pink ceramic floral tiles.

A pair of flamboyant recently restored structures anchor the junction of Veerasamy Road and Jalan Besar. When first sketched in 1987 trees sprouted from the balconies of the houses and their future was uncertain.

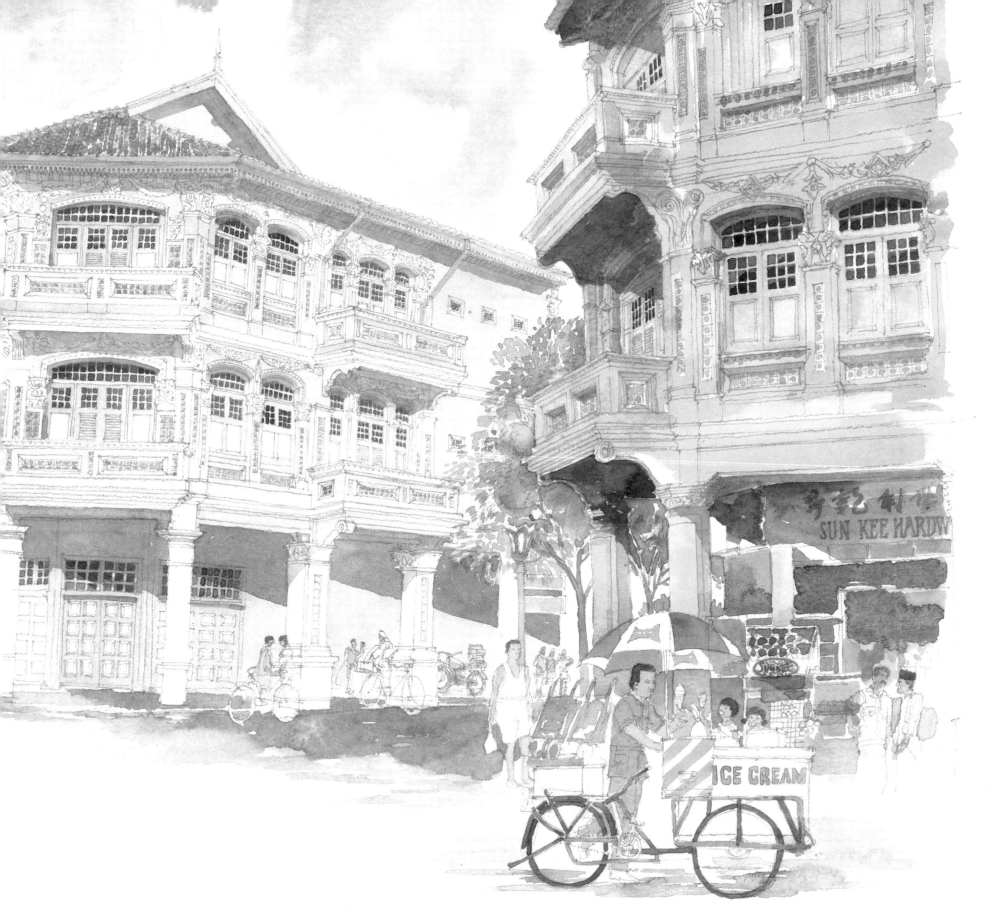

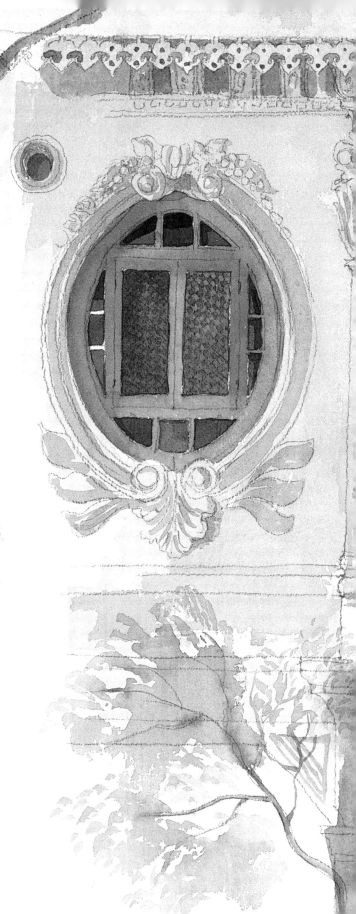

This unusual façade is from a particularly robust grouping of nine shophouses along Syed Alwi Road which are rich in form, texture and decoration. The unique circular windows are not unlike the windows of Victoria Concert Hall.

A verandah with classic columns takes the eye in Syed Alwi Road.

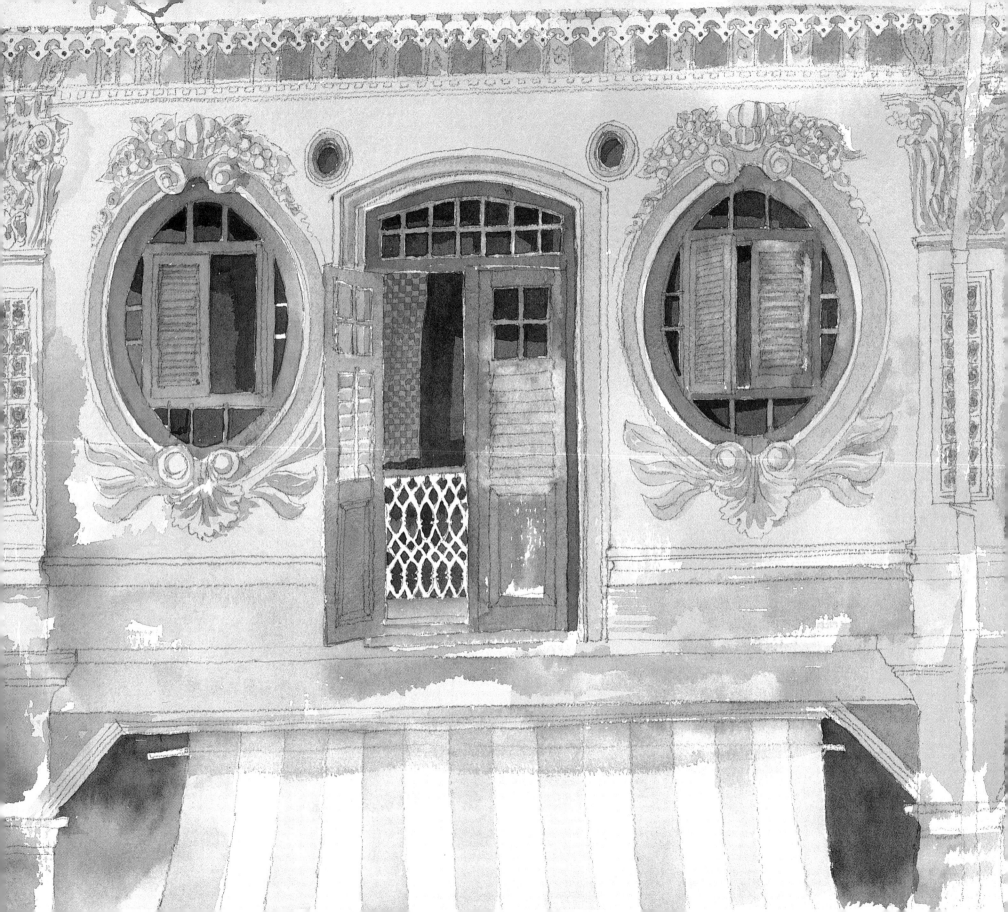

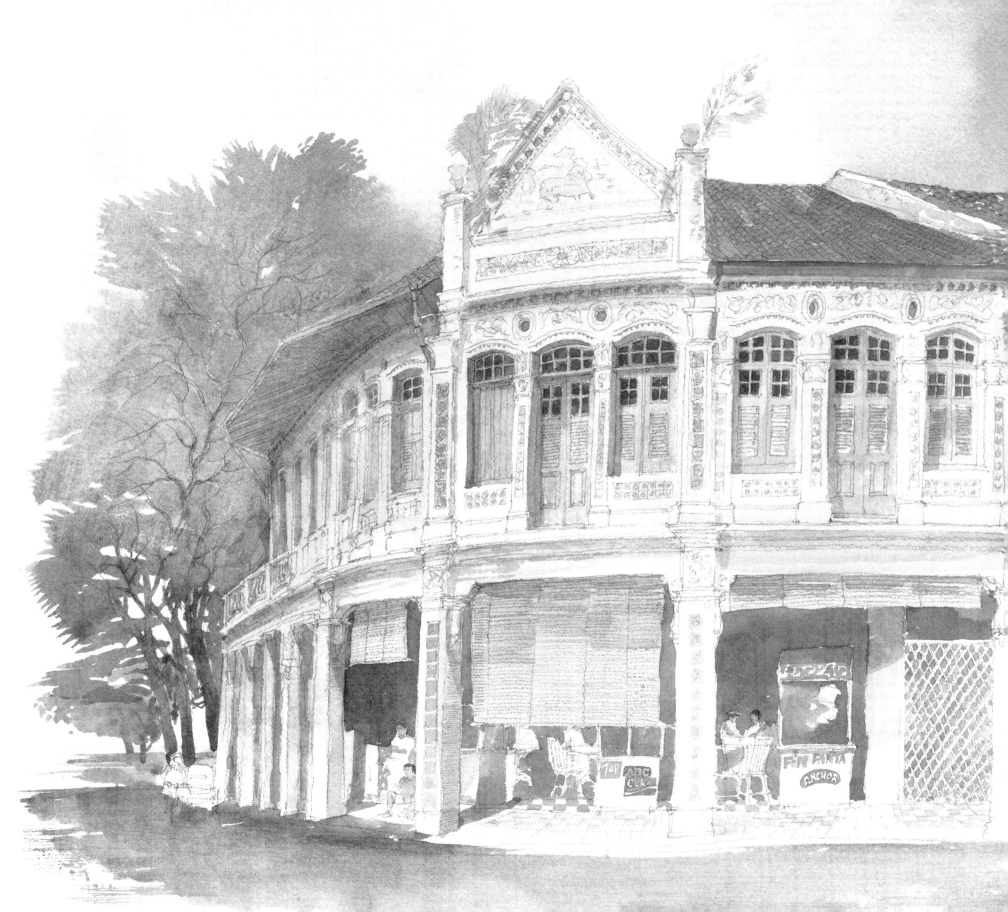

Balestier Road is a fascinating blend of old and
new. The street still contains many buildings
of historical interest, such as this splendid and
recently restored coffee shop.

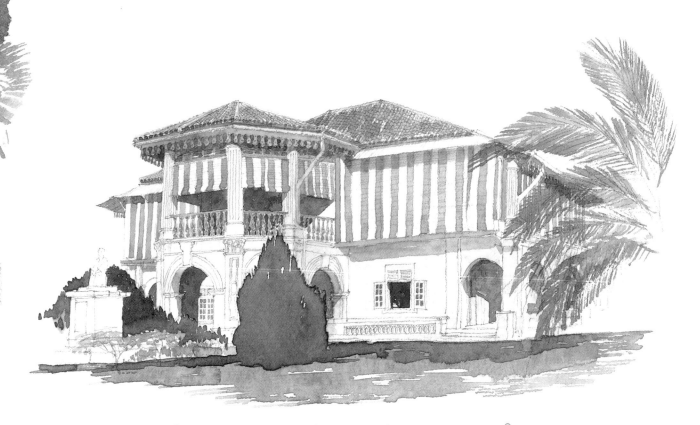

Symmetrical in form with porch, verandahs,
hipped roof, arches and pseudo-Renaissance
features, Sun Yat Sen Villa is a classic
example of the Victorian villas that dominated
shady suburbs. Once headquarters of Sun Yat
Sen's revolutionary movement in Singapore,
it is now a National Monument and a
museum open to the public.

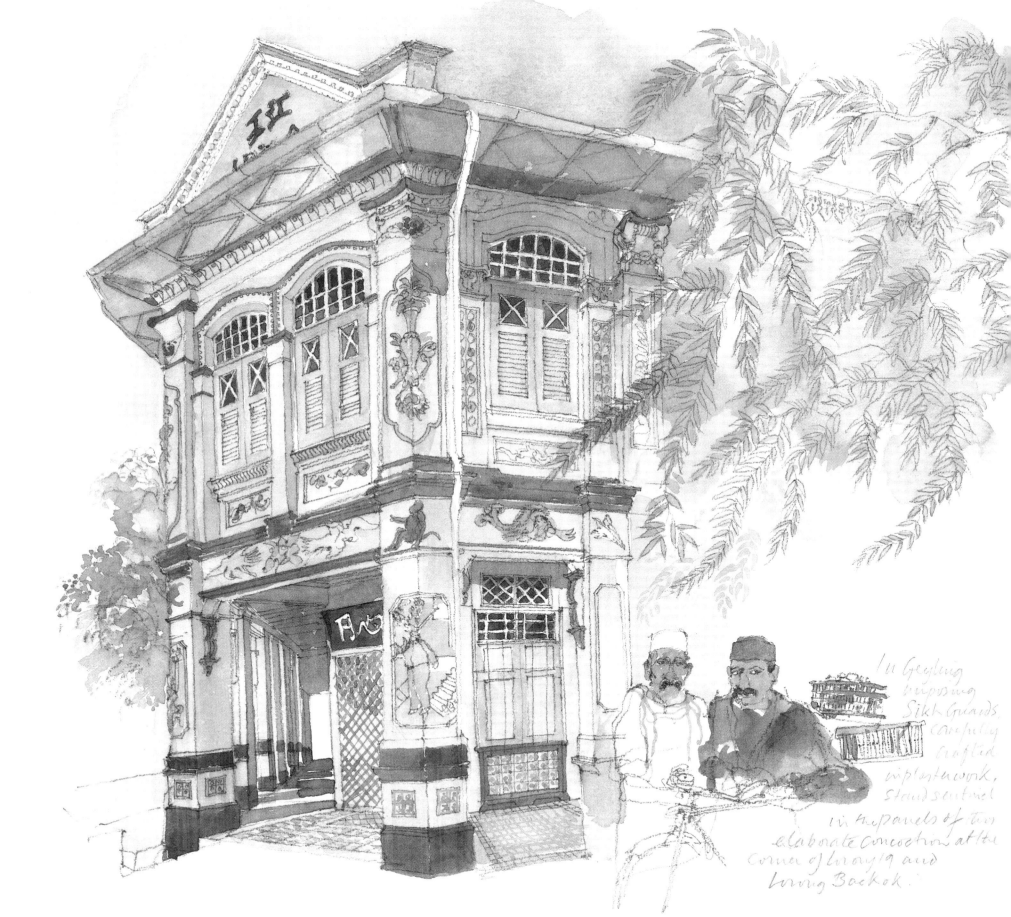

In Geylang imposing
Sikh Guards
carefully
crafted
in plasterwork,
stand sentinel
in the panels of two
elaborate concoction at the
corner of Lorong 19 and
Lorong Bachok.

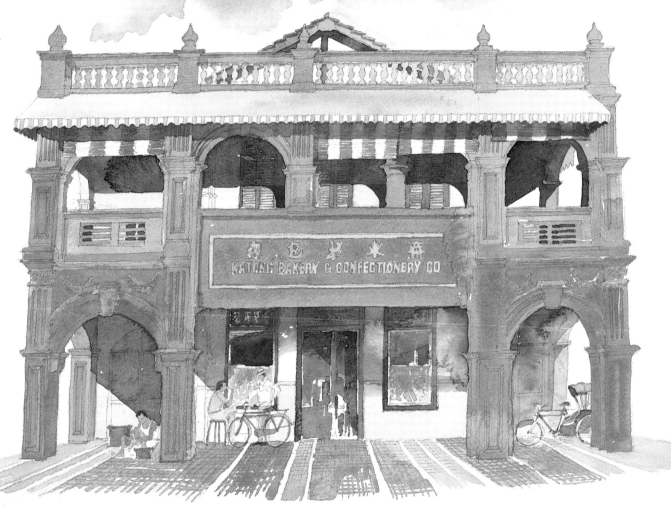

The Katong Bakery & Confectionery Company
has been an East Coast Road Landmark
for decades. Known among the cognoscenti
as 'The Red Bakery' it still prepares and
serves coffee, tea and pastries in
the old-fashioned way.

Classic Terraces

Shophouses are narrow, small-scale terraced structures that were typically built in contiguous blocks with individual units sharing party walls. Before the advent of modern construction methods, the shophouse was the predominant building form, not only in Singapore but in most South East Asian towns and cities as well. It was the ideal unit for small-scale family-based business because the ground floor could be used for trade and the upper floors as living quarters.

With suburban expansion and rising affluence in the early years of this century, an increased number of purely residential terraces were erected. This was at a time when good architectural manners consisted of conforming to the established theme. Harmony and grace were attained through the overall unity of the structures, especially the regular proportions of frontages, depths and floor heights. Then onto the shells were crafted a profusion of eclectic details, ranging from Malay fretwork to European classical pilasters, columns, pediments and plasterwork, to air vents in Chinese shapes and decorative scrolls.

Emerald Hill, Blair Road and Koon Seng Road contain classic examples of early 20th-century residential terraces. These are gazetted conservation areas which have experienced a flurry of restoration activity. While the approaches to conservation have varied widely — from the radical altering of the space within a building shell, to a conservative renovation which retains the original spaces and finishes — the enthusiasm of the new owners has been consistent and injected remarkable new vitality into these charming neighbourhoods.

No 12 Koon Seng Road.
Along Koon Seng Road are two facing rows of highly ornate terrace houses which illustrate Singapore's eclectic Straits Chinese-influenced domestic architecture at its best.

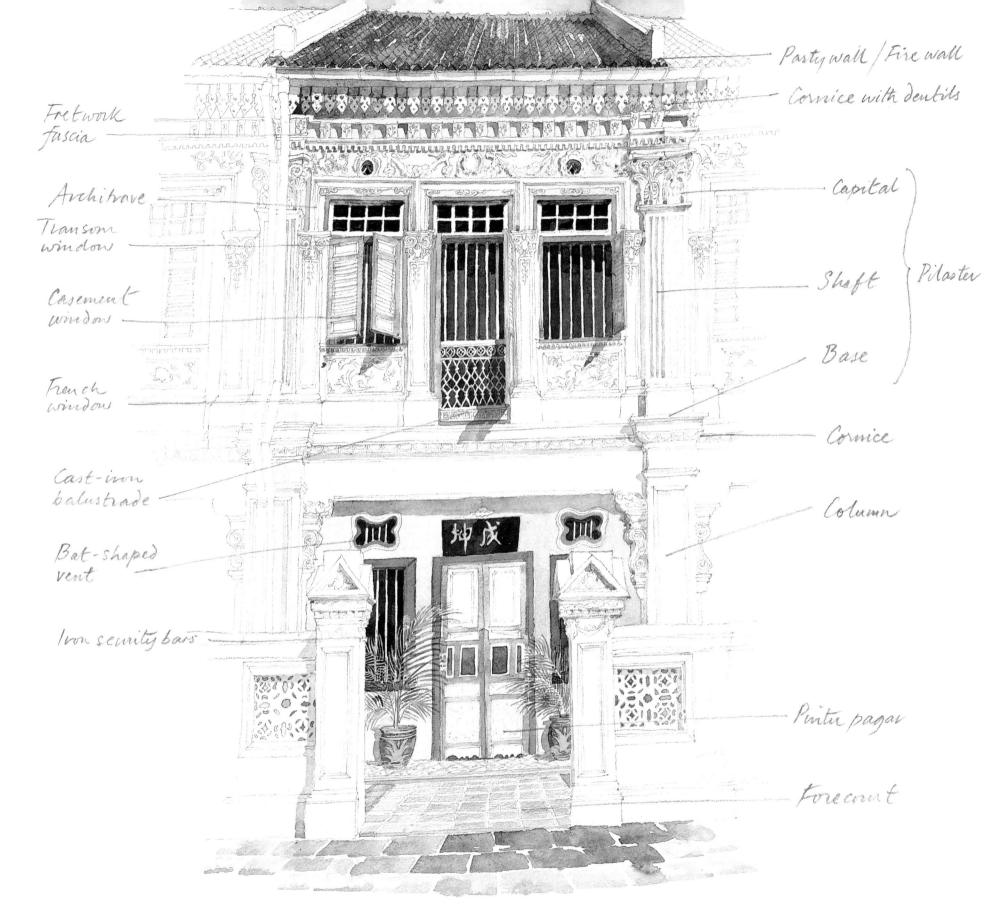

Party wall / Fire wall

Cornice with dentils

Fretwork fascia

Architrave

Transom window

Casement window

French window

Cast-iron balustrade

Bat-shaped vent

Iron security bars

Capital

Shaft

Base

Pilaster

Cornice

Column

Pintu pagar

Forecourt

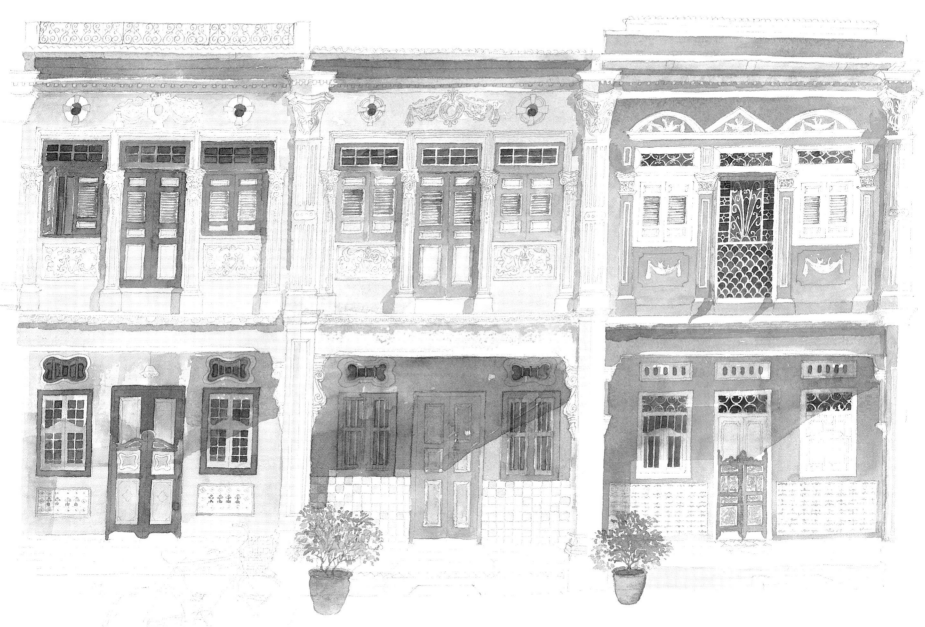

Blair Road has become a highly desirable address.
Here a trio of classic façades along the side
where the houses are linked together
by a five foot way.

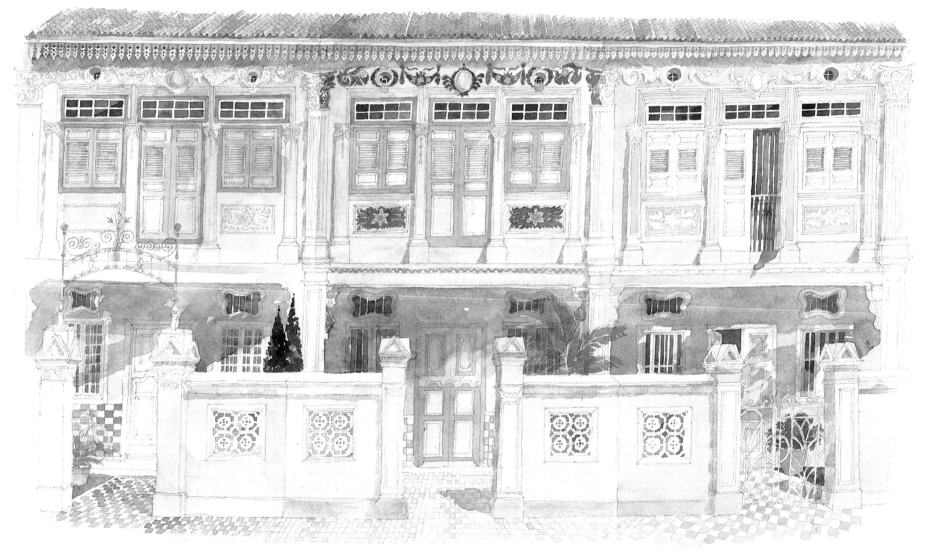

Most of the houses along the opposite side
of Blair Road have generous fore courts.
Among the street's newer occupants
are artists and other creative people
who have easily settled into the
historic neighbourhood.

Details such as gate posts, elaborate plasterwork and decorative tiles reveal the richness of Blair Road's houses.

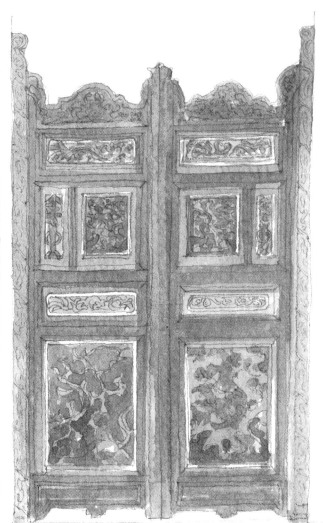

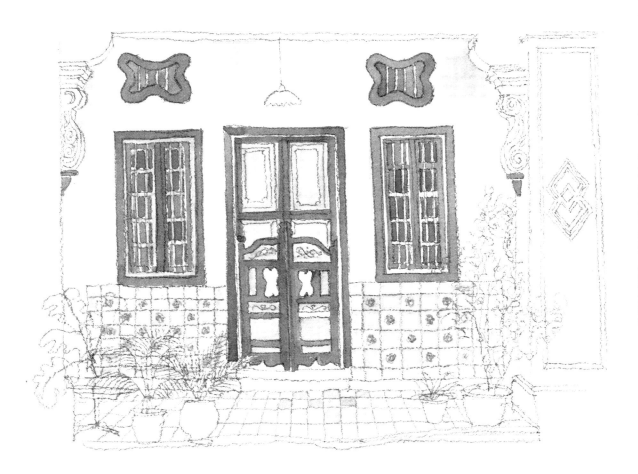

The pintu pagar, or half doors placed in front of main doors, are extremely practical as they afford privacy while giving ventilation when the main door is open.

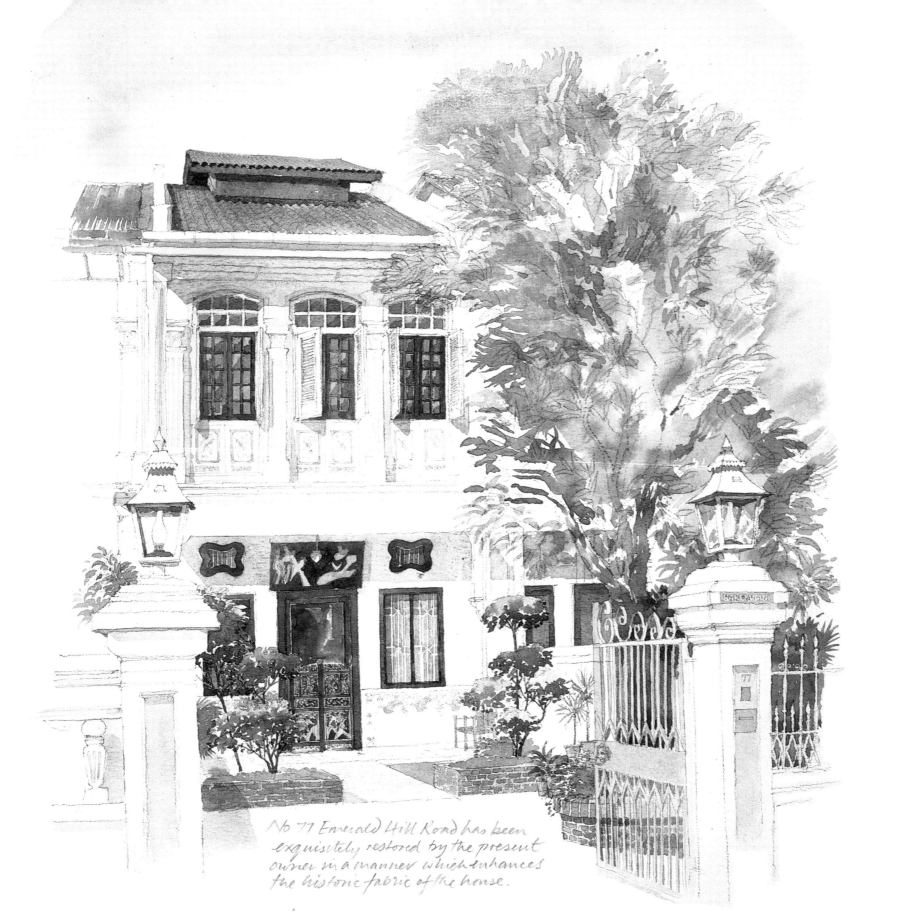

No 77 Emerald Hill Road has been exquisitely restored by the present owner in a manner which enhances the historic fabric of the house.

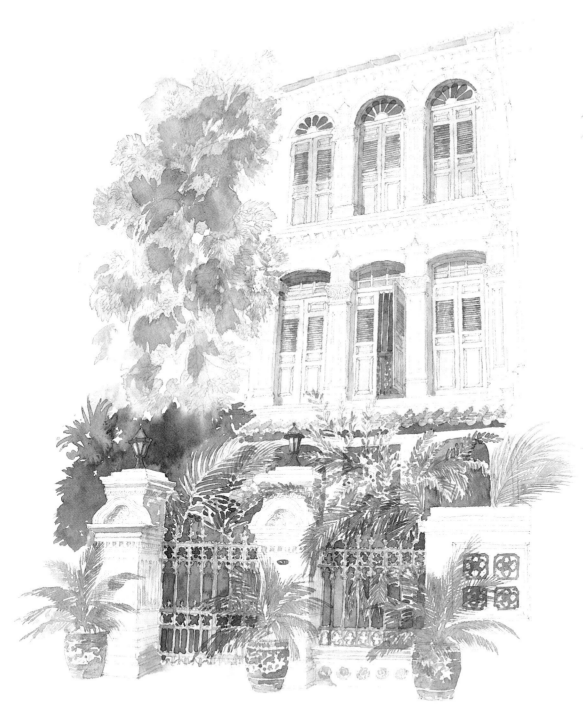

An imposing group of three-
storey terrace houses along
Emerald Hill Road. The
first designated Conservation
Area, selected in 1981,
Emerald Hill has a
marvellous sense of history
and human scale as well
as many fine and varied
examples of residential
terrace houses. Like
Blair Road, it has also
become a highly desirable
address.
At No 41 (left) the façade,
gate and cast-iron railings
have been as meticulously
restored as the interior by
the present owners.

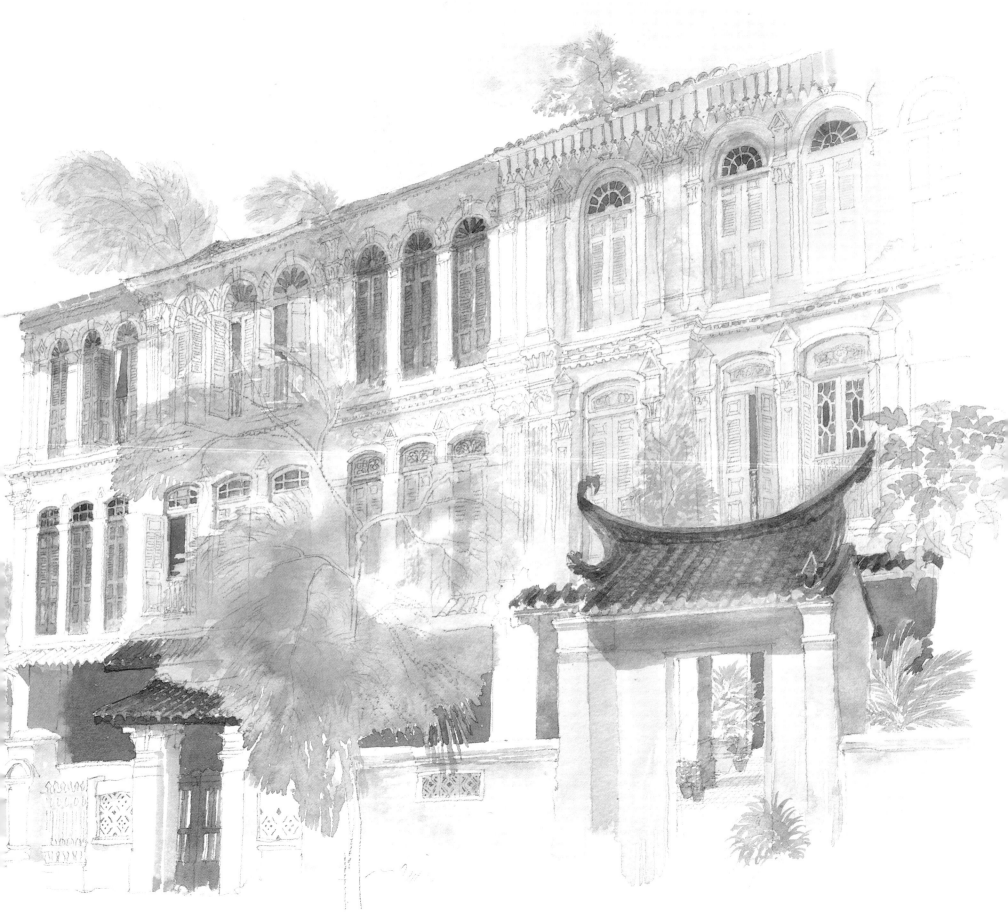

Bungalows and Parks

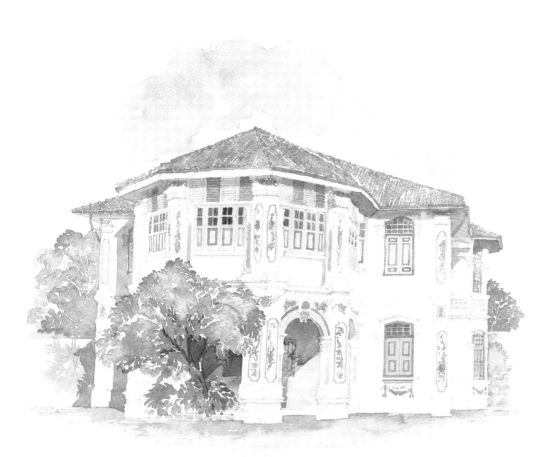

Bungalows with Straits Chinese
flavour set within neat garden compounds
such as this one along Mountbatten
Road have become a rare sight in
Singapore's suburbs.

'Boscombe', No 40 Nassim Road (right)
Shaded by large old trees, Nassim Road is a
favoured location of embassies and
diplomatic residences. This house was,
from 1966 to 1990 the residence of the United
States Naval Attaché in Singapore

Strictly speaking, the term 'bungalow' refers to a single-storey residence elevated above the ground. In the Singaporean context, however, the term has evolved to describe any dwelling which sits within its own grounds. In the wake of rapid urbanization, many wonderful bungalows built before World War II have been demolished. Fortunately, those that remain are now regarded with considerable affection. As most were built in the days before air conditioning, they are also widely recognized as offering important lessons in designing for tropical living.

A distinct type of bungalow often associated with colonial Singapore and Malaya is the Black-and-White house, a synthesis of mock-Tudor style, which enjoyed popularity in late 19th-century Britain, and the indigenous Malay kampong house. The style was adopted by colonial engineers who planned the verdant former colonial enclaves of Goodwood Hill, Adam Park, Ridley Park, Alexandra Park, Mount Pleasant and Malcolm Road. The park-like atmosphere was enhanced by the absence of boundary walls, the setting of the bungalows amidst broad expanses of lawn, curving driveways and judicious planting.

In 1991, some 70 bungalows were identified for conservation as being 'of outstanding architectural and constructional quality and living examples of buildings representing the culture and lifestyle of a period in Singapore's history.' Not gazetted for conservation, but under the care of the Government, are the many Black-and-White houses managed by the Urban Development and Management Corporation.

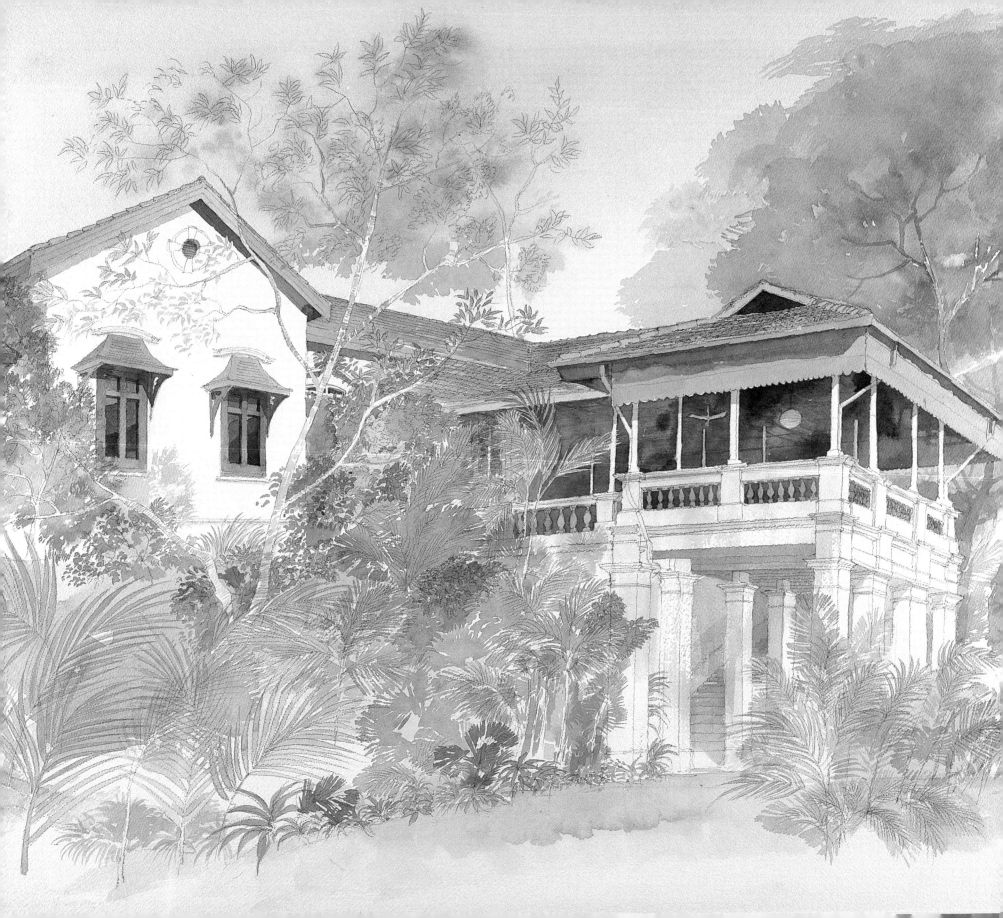

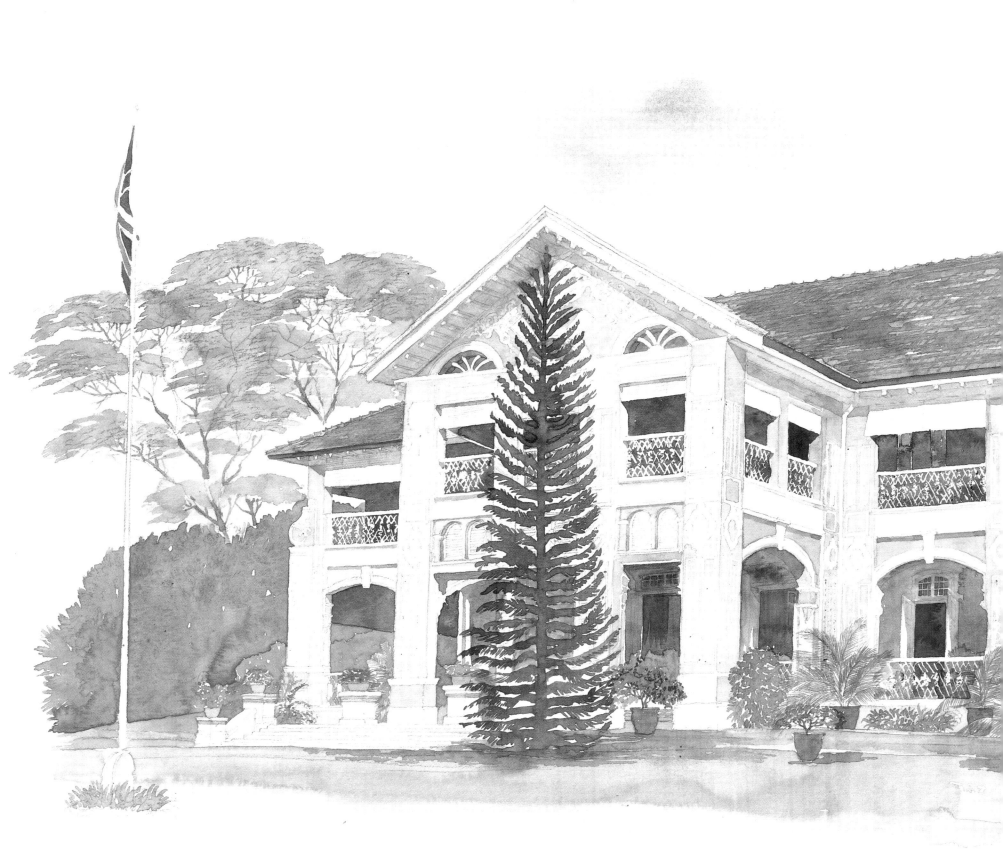

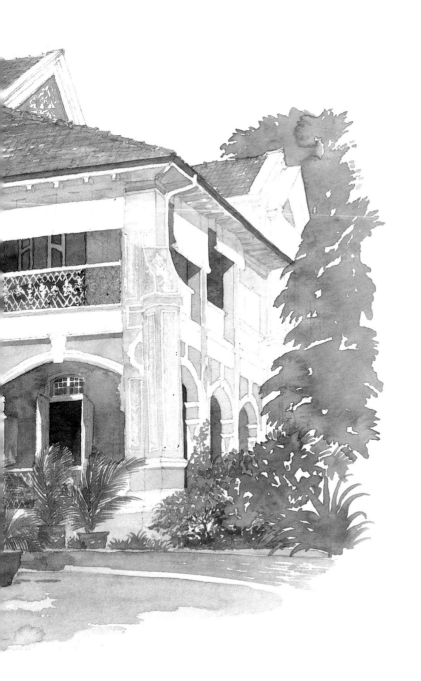

Eden Hall, the residence of the British
High Commissioner to Singapore, was built
in 1904. Beautifully situated within
extensive grounds, the house is lovingly cared
for by the current High Commissioner
and his wife and contains a
charming garden room (above)
overlooking a paved terrace.

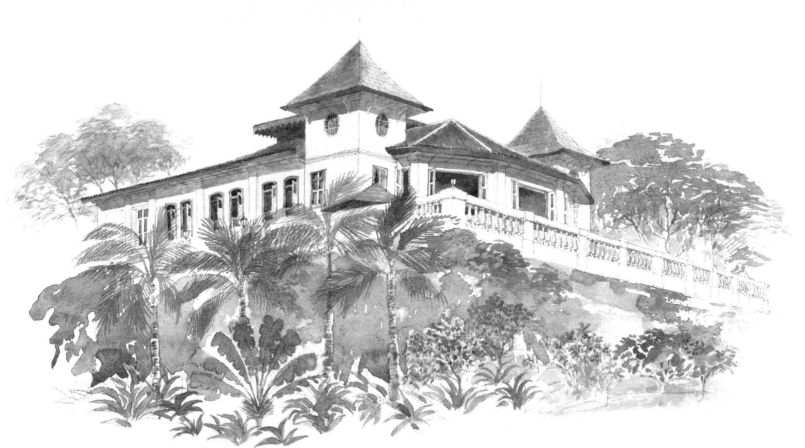

Alkaff Mansion. Built in the early years of the century by Syed Abdul Rahman Alkaff as a family retreat, the house was abandoned after World War II, rediscovered in the 1980s and has been restored as a unique restaurant.

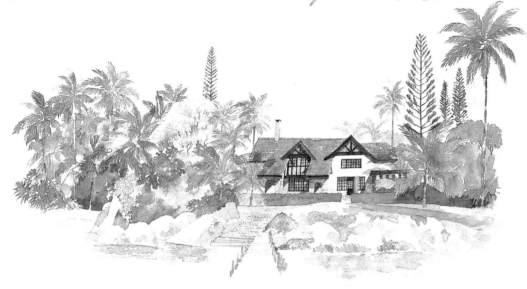

A tranquil bungalow survives on Pulau Ubin

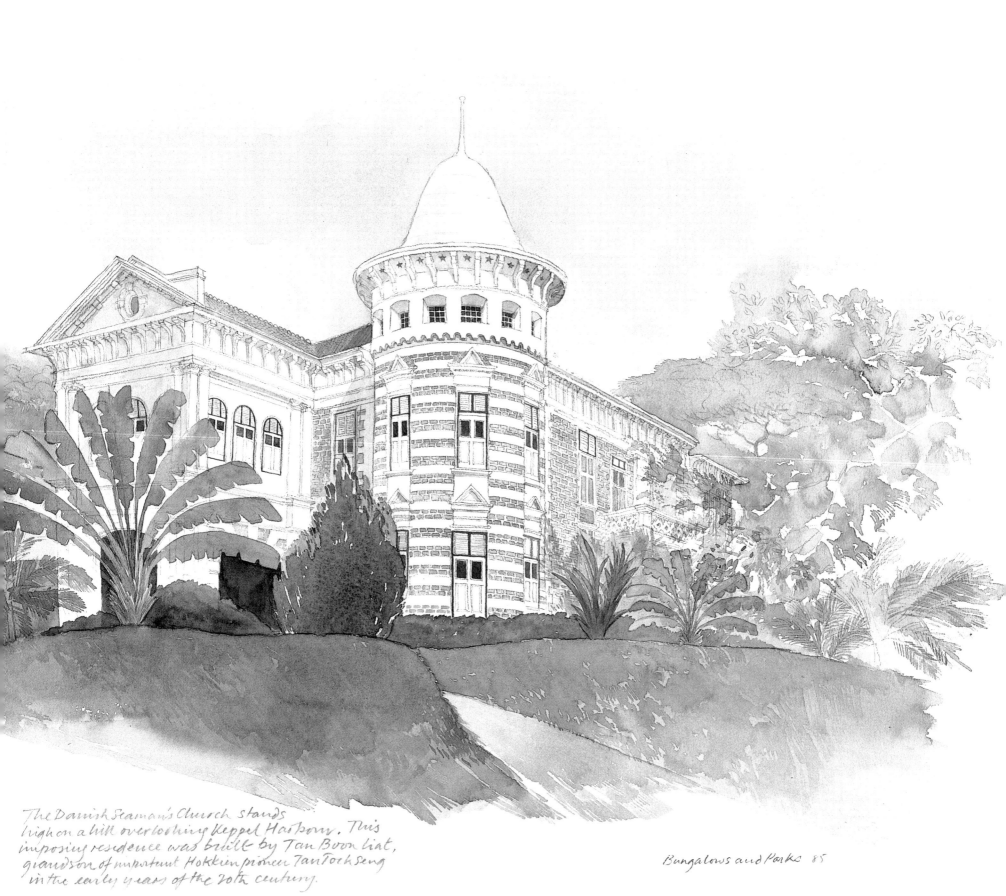

The Danish Seaman's Church stands
high on a hill overlooking Keppel Harbour. This
imposing residence was built by Tan Boon Liat,
grandson of important Hokkien pioneer Tan Tock Seng
in the early years of the 20th century.

Bungalows and Parks 85

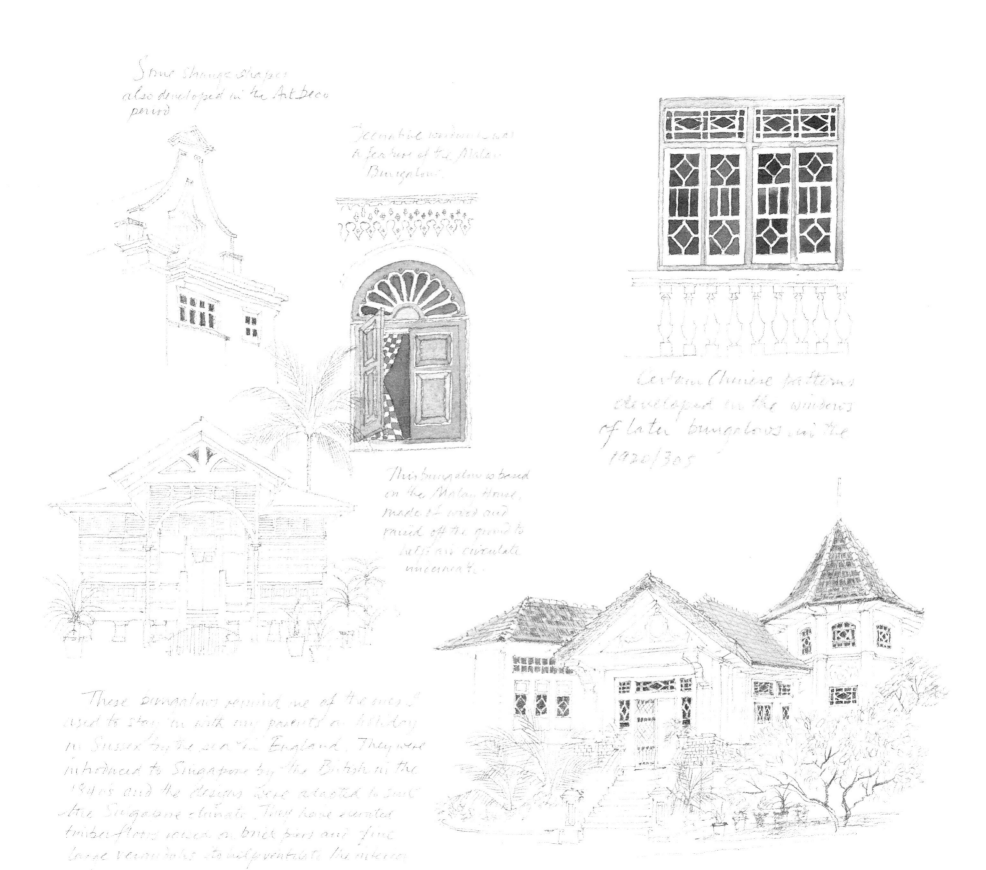

Some strange shapes
also developed in the Art Deco
period

Decorative woodwork was
a feature of the Malay
Bungalow.

This bungalow is based
on the Malay House,
made of wood and
raised off the ground to
help air circulate
underneath.

Certain Chinese patterns
developed on the windows
of later bungalows in the
1920/30s

These bungalows remind me of the ones I
used to stay in with my parents on holiday
in Sussex by the sea in England. They were
introduced to Singapore by the British in the
1840s and the designs were adapted to suit
the Singapore climate. They have raised
timber floors reised on brick piers and have
large verandahs to help ventilate the interior.

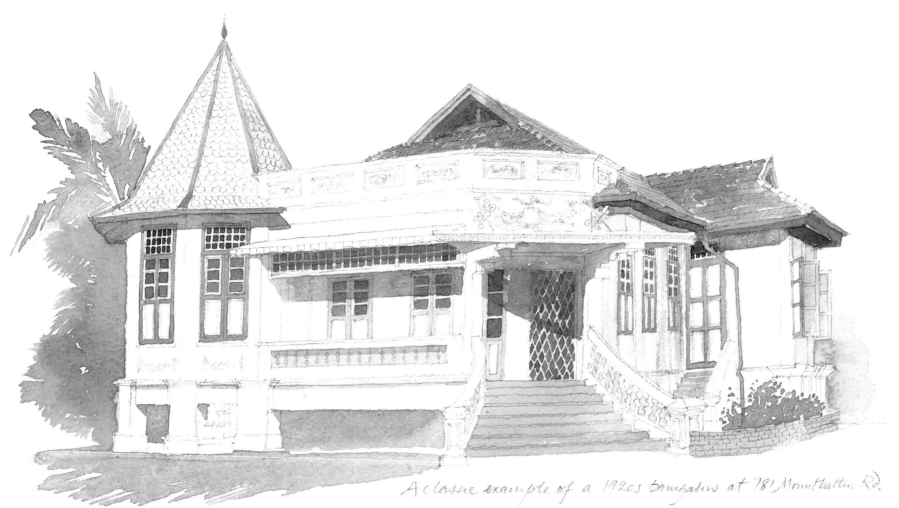

A classic example of a 1920s bungalow at 781 Mountbatten Rd.

A very grand verandah.
An indulgent 'extra' was built in 1929 to elevate
the ordinary bungalow above its neighbours.

Bungalows and Parks 87

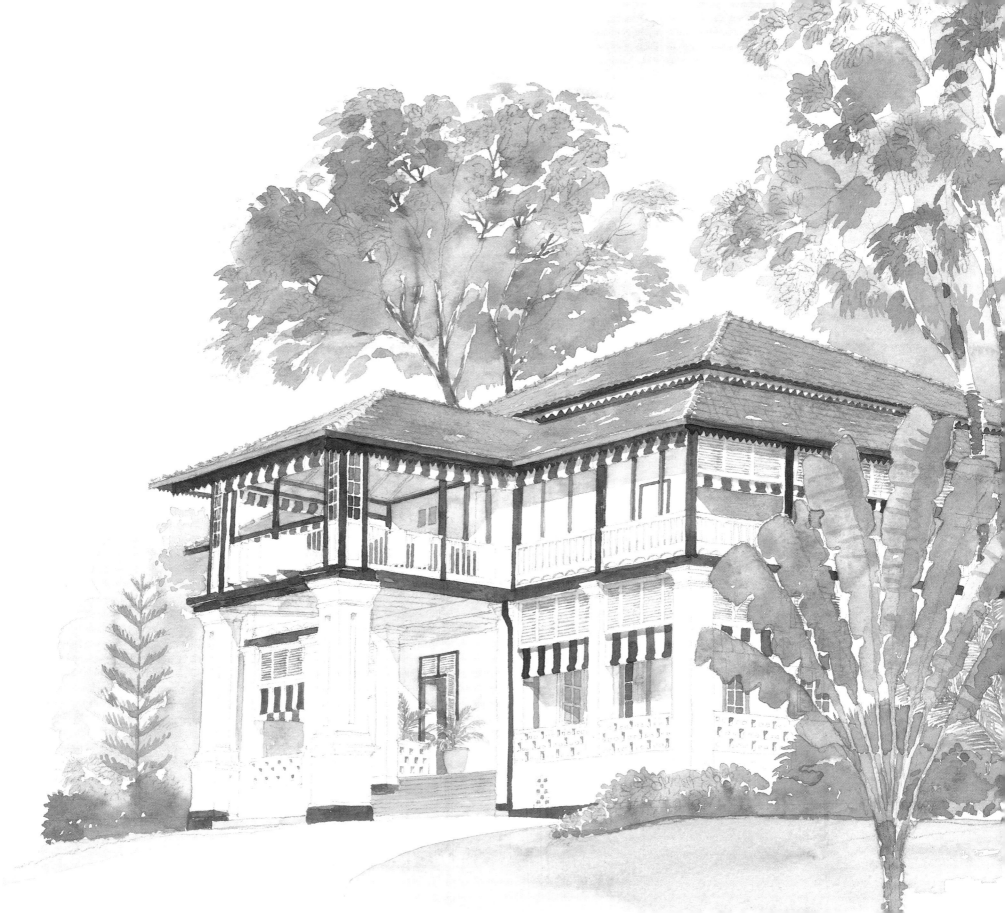

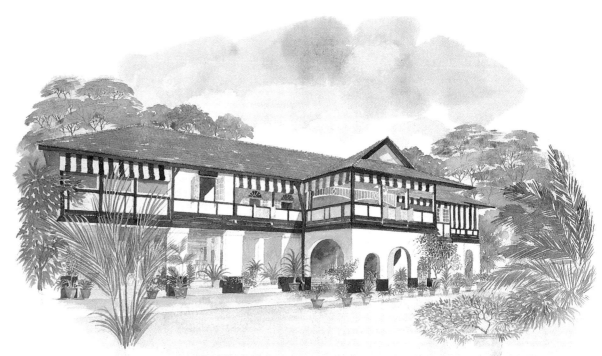

Early examples of black-and-white bungalows include Goodwood Hill (left) Ridley Park (above) and Burkill Hall (below) which was built in 1866 and served as the home of several directors of Botanic Gardens.

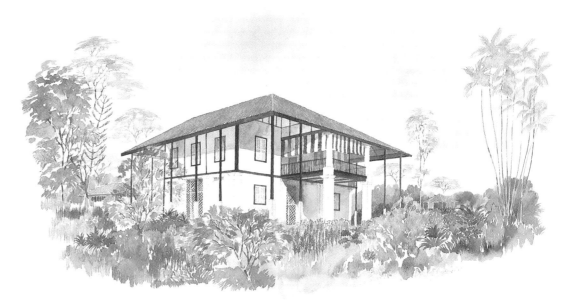

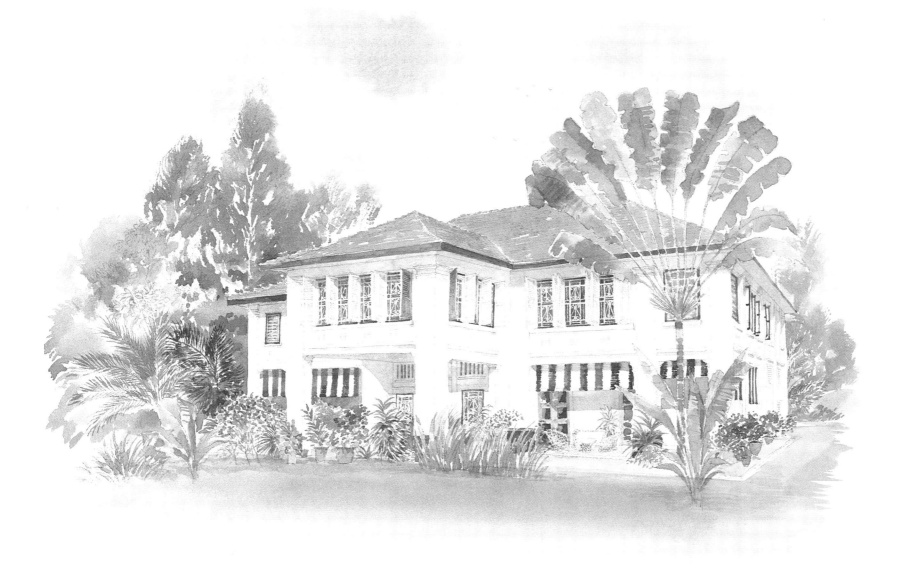

No 6 Cornwall Road is a
typical example of the
handsome bungalows
found in Alexandra Park.

Built in 1936 as an
officers' mess this Alexandra
Park bungalow was,
until mid 1995, the premises
of Winchester School.

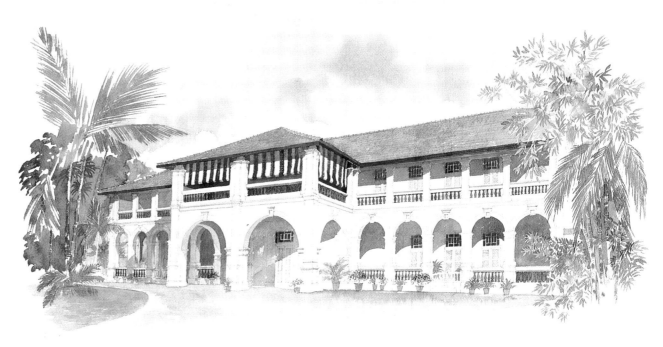

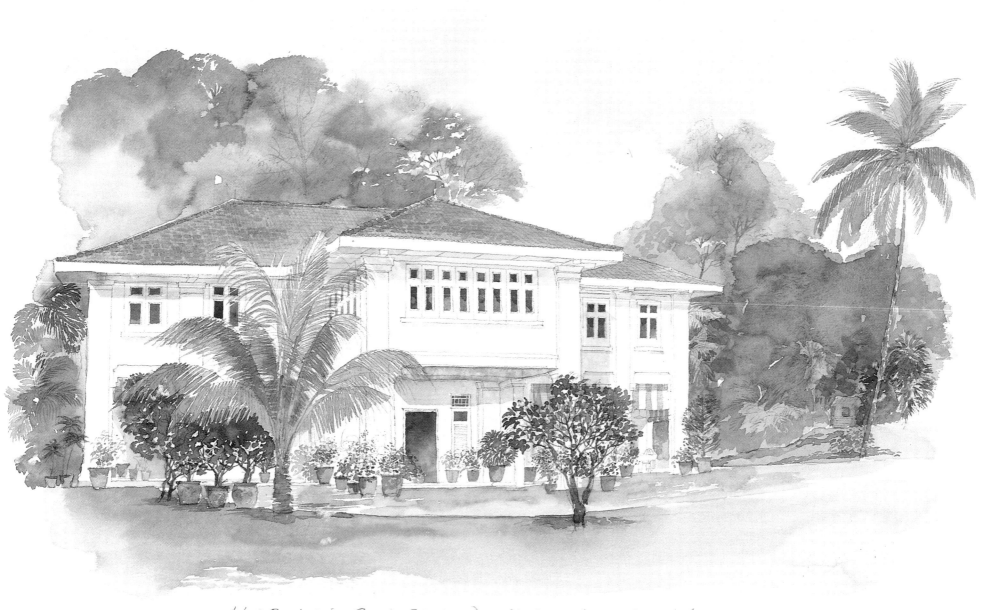

No 5 Berkshire Road. Black-and-White bungalows originated
as a synthesis of the mock-Tudor and indigenous Malay kampong houses.
The style was adopted in various guises by colonial government
engineers who designed the houses for government servants in
places such as Goodwood Park, Adam Park, Malcolm Road
Ridley Park and Alexandra Park.

THE CIVIC SPIRIT

Page 18

Caldwell House (formerly Convent of the Holy Infant Jesus), Victoria Street
Built in 1840–41. Architect: George Coleman.
Gazetted a National Monument on 26 October 1990.
In 1852 the house was purchased by Father Nain who eventually bought all nine land lots between Victoria Street and North Bridge Road for a cloistered convent and school. When the Convent of the Holy Infant Jesus relocated to Toa Payoh, the site, including Caldwell House, became a restaurant and cultural complex known as CHIJMES.

Page 19

Empress Place Building, Empress Place
Built in 1864–65, with subsequent additions. Architect: J.F.A. McNair.
Gazetted a National Monument on 14 February 1992.
These former offices housed the Immigration Department, the Registry of Births and Deaths and the Citizenship Registry until restored in 1989 as a private exhibition venue. In 1995 the building was taken over by the National Heritage Board.

Victoria Theatre and Concert Hall, Empress Place
Built in 1856–62 (Theatre) and 1905 (Concert Hall), with subsequent refurbishments in the mid 1950s and 1979–80.
Gazetted a National Monument on 14 February 1992.
The oldest portion is the Theatre, which opened as the Town Hall in 1862. To commemorate the Jubilee celebrations of Queen Victoria the community decided to build a new theatre. The Town Hall was re-faced and integrated with the new Victoria Memorial Hall by a 60m (197-foot) clock tower. The People's Action Party held its inaugural meeting on 21 November 1954 in Victoria Memorial Hall. Renovated in the late 1970s to serve as home of the Singapore Symphony Orchestra, it is now known as Victoria Concert Hall.

Page 20

Parliament House, Empress Place
Built in 1827, with subsequent alterations. Architect: George Coleman.
Gazetted a National Monument on 14 February 1992.
The house was commissioned by a wealthy Java merchant, J.A. Maxwell. Built on land designated for government use in Raffles' Town Plan, it was never lived in and was instead leased by the government and used as a court house and government offices. Since independence, it has been the seat of Parliament.

Page 21

Istana Negara (formerly Government House), Orchard Road
Built in 1867–1869. Architect: J.F.A. McNair.
Gazetted a National Monument on 14 February 1992.
Set amidst park-like grounds that are open to the public on Public Holidays, this arcaded mansion is the official residence of the President of Singapore. It was built as the residence of the Governor of the Straits Settlements by Indian convict labourers who made their own bricks and plaster.

Page 22

Fullerton Building , Fullerton Square
Built in 1925–28, with subsequent alterations. Architect: Keys & Dowdeswell.
The design of this heavy pseudo-classical building was selected from an open competition. Named after Robert Fullerton, Governor of Singapore 1826–1829, this former General Post Office is to become a luxury hotel.

Page 23

Supreme Court Building, St. Andrew's Road
Built in 1937–1939. Architect: Public Works Department (Frank Dorrington Ward).
Gazetted a National Monument on 14 February 1992.
This was the last major government building constructed in pre-war Singapore. On the façade is a fine pediment sculpture, an allegory of Justice executed by Cavalieri Rodolfo Nolli, one of a group of Italian artists who arrived in Bangkok in 1913 to build a new throne room for the King of Siam.

Singapore Cricket Club, Connaught Drive
Built in 1884 (central pavilion), with subsequent additions including a major facelift circa 1906 and the addition of north and south wings in 1922–23. Architect: Swan & Maclaren.
Gazetted a Conservation Area on 2 December 1994.
Evidence of cricket's popularity in Singapore dates back to 1837 when it was recorded that complaints were made about gentlemen playing the game on the Esplanade on Sunday. A meeting was held to establish the Singapore Cricket Club in 1852 and the game rapidly gained popularity.

Page 24–25

National Museum, Stamford Road
Built in 1887. Architect: Henry McCallum, Colonial Engineer.
Gazetted a National Monument on 14 February 1992.
The National Museum began life as a double entity called the Raffles Library and Museum, its primary focus being natural history. As a colonial institution, the largely British staff were mainly concerned with providing services for their compatriots. From the 1960s, the museum embarked on a programme to build collections reflecting the cultural and intellectual interests of the nation. In 1992 plans for a museum precinct were unveiled, and in 1993 the National Heritage Board was established to implement them. The National Museum has been designated as the Singapore History Museum.

Singapore Art Museum (formerly St. Joseph's Institution), Bras Basah Road
Built in 1867 (central block), with subsequent additions. Architect: Brother Lothaire.
Main building gazetted a National Monument on 14 February 1992; classrooms gazetted a National Monument on 3 July 1992.
St. Joseph's Institution opened in 1852 in a small Catholic chapel erected on the site in 1830. The foundation stone of the present building was laid in 1855, but it was not completed until 1867 due to lack of funds. The curved wings of the main building were added by another priest architect, Father Nain, around 1906. The school was relocated out of the central area and the buildings taken over by the National Heritage Board.

Asian Civilisations Museum (formerly Tao Nan School), Armenian Street
Built in 1910. Restoration and museum conversion 1995–96. Architect: Swan & Maclaren.
Located on quiet Armenian Street near the historic Armenian Church. Tao Nan School was founded by Chinese philanthropists in 1903. The school relocated to more spacious premises in Marine Parade and the building sat vacant for some years until it was incorporated into the National Heritage Board's museum precinct.

Page 26–27

Raffles Hotel, Beach Road
Opened in 1887 in a bungalow known as Beach House; first extension 1889; Palm Court Wing 1892; Demolition of Beach House and construction of Main Building 1899; Bras Basah Wing 1904; Bar and Billiard Room circa 1907. Closed March 1989 for restoration and redevelopment. Reopened on 16 September 1991. Main Building and Bras Basah Wing architect: R.A.J. Bidwell of Swan & Maclaren.
Gazetted a National Monument on 6 March 1987.
Raffles Hotel opened humbly in a spacious bungalow. Under the guidance of the astute and enterprising Sarkies brothers, who also founded the Strand in Rangoon and the E&O in Penang, it expanded continuously until by 1910 the hotel as it is today was in place. It was the opening of the Main Building in 1899

that signalled Raffles' transformation from hostelry to Grand Hotel as it was built on a scale and offered services hitherto unseen in the port city.

Page 28
Commercial buildings, Orchard Road
Built in the 1920s.
Originally plantation land and then a popular site for villas, tree-lined Orchard Road was frequently compared to picturesque British lanes by early travellers. Its transformation into a commercial area began in earnest in the early years of this century and since then, frequent redevelopment has been the norm. This row is the only visual reminder of Orchard Road before the days of shopping malls.

Page 28
Goodwood Park Hotel Tower Block, No. 22 Scotts Road
Built in 1900. Architect: R.A.J. Bidwell of Swan & Maclaren. Gazetted a National Monument on 23 March 1989.
Built by the German community as their Teutonia Club, the building was confiscated by the colonial authorities during World War I when all German residents were interned. Postwar the building was reopened as a venue for concerts, talks, film shows and receptions by the Manasseh brothers who named it Goodwood Hall, and it was here in 1922 that Anna Pavlova danced. Since 1929 it has been the Goodwood Park Hotel.

Page 29
MPH Building, corner of Stamford Road and Armenian Street
Built in 1908. Architect: Swan & Maclaren.
This example of Edwardian commercial architecture was built as the Methodist Publishing House headquarters in 1908. Today it is one of Singapore's busiest bookstores, complete with café, and an important landmark along Stamford Road.

Page 30
Stamford House, No. 39 Stamford Road
Built in 1904. Architect: R.A.J. Bidwell of Swan & Maclaren. This three-storey building was commissioned by Seth Paul who named it Oranje Building. During the 1920s it was leased by the Sarkies brothers who used it as an annex of Raffles Hotel and christened it The Grosvenor. There are many noticeable design similarities between it, portions of Raffles Hotel and the Goodwood Park Hotel tower block, as all were designed by the same architect.

Page 31
Telok Ayer Market (Lau Pa Sat), Robinson Road
Built in 1894. Architect: Municipal Council of Singapore with cast iron supplied by William MacFarland of Glasgow. Gazetted a National Monument on 6 July 1973.
There has been a market on this site since 1824. The present elegant Victorian structure was designed by Municipal Engineer James MacRitchie, after whom MacRitchie Reservoir is named. The ornamental cast iron was manufactured by William MacFarlane & Co. of Glasgow. After renovations in the 1970s, it became a popular food centre. During construction of the Mass Rapid Transit railway the structure was dismantled, then reinstated. It was then turned into a Festival Market.

ALONG THE RIVER

Page 33, 34–35
Shophouses, Boat Quay
Mostly late 19th and early 20th century. Various architects. Gazetted a Conservation Area 7 July 1989.
Originally a swamp that was filled in according to orders from Sir Stamford Raffles, Boat Quay runs along the southern side of the Singapore River. Here the early business pioneers built their offices and godowns. Even after a new harbour was built at Tanjong Pagar in 1852, most of the shipping business was carried out at Boat Quay. Only after it was gazetted a Conservation Area did the traders move out to make way for restaurants, pubs and cafés.

Page 36–37
Singapore River Bridges
Cavenagh Bridge
Built in 1868–69. Architect: Public Works Department. Named after Major-General William Orfeur Cavenagh, Governor of Singapore 1859–1867, and built with cast iron shipped from Glasgow by P.W. MacLellan, Engineers.

Coleman Bridge
There has been a bridge here since 1822, although it has been improved and widened many times. It is named after the architect and government surveyor G.D. Coleman. The present bridge is recent and was designed to retain the architectural and decorative features of the earlier structure.

Elgin Bridge
Elgin Bridge connects North Bridge Road and South Bridge Road. The present bridge, which was constructed in the mid 1920s, is the fifth on the same site for it was here that the first bridge that crossed the river was built in 1819. That footbridge was called Presentment Bridge or Monkey Bridge.

Page 38–39
Shophouses and godowns, Clarke Quay
Built mostly late 19th to early 20th centuries. Various architects. Gazetted a Conservation Area on 7 July 1989.
There is a pleasing symmetry to Clarke Quay. The area consists of shophouses, that are intersected by a pair of roads at right angles anchored by a central open space. No longer a hardy warehouse and factory district, Clarke Quay has been transformed into a festival village. Yet the quality of a small, village streetscape has been retained.

CHINATOWN
Chinatown was gazetted a Conservation District on 7 July 1989.

Page 40
Thian Hock Keng, Telok Ayer Street
Built in 1841.
Gazetted a National Monument on 6 July 1973.
This is Singapore's oldest Chinese temple, and was built by the Hokkien community. For many years it fronted the sea. The present buildings were executed by master craftsmen and the building materials especially imported from China.

Page 42
Pagoda Street
Pagoda Street was already built up by the 1860s but the present shophouses date from the early 20th century. Like many of Chinatown's buildings before the present conservation effort, these showed the strains of decades of overcrowding and neglect. Yet their refined Classical details inevitably made an elegant architectural statement. In 1972, Queen Elizabeth was brought for a stroll down this "museum" lane as part of her state visit.

Page 43
Trengganu Street
Bustling Trengganu Street is usually thought of as the heart of Chinatown and has long held a special place in the hearts of Singaporeans. Although restoration has brought change to the commercial activities of the street, it is still a crowded, busy thoroughfare throughout the day and well into the night.

Page 44-45
Amoy Street/Telok Ayer Street
Telok Ayer Street and Amoy Street together remain one of Singapore's most fascinating areas, partly because of the concentration of religious buildings and clan associations along Telok Ayer Street, and partly because of the street activity and concentration of 19th and early 20th century two-storey and

three-storey shophouses which still dominate the streets.

Page 46
Jinricksha Building, junction of Neil Road and Tanjong Pagar Road
Built in 1903. Architect: Municipal Council of Singapore.
The Jinricksha, a vehicle which is drawn by a human puller with his hands on a pair of shafts and his feet running at a steady pace, was introduced from Shanghai to Singapore in 1880 and was a familiar site until phased out in the 1930s. The building acts as a strong visual anchor and has a dignity and presence that transcends its actual dimensions. After the days of the Jinricksha, it was for many years a maternal and child-care centre. It now houses a restaurant and offices.

Page 47
Tanjong Pagar Road
Tanjong Pagar Road leads out from town in a southwesterly direction towards the dock area. Its development was closely linked to the growth of steamship activities at the Tanjong Pagar docks from the 1860s onwards. The road became one of the main thoroughfares for moving goods between riverside warehouses and the docks.

Page 48
Ann Siang Hill
This was first known as Scott's Hill after its owner, Mr. Charles Scott, who cultivated nutmeg and cloves. Upon Scott's death the land was sold to Mr. Ann Siang, a rich sawmill owner after whom the street is named. The high ground conveniently located behind the more densely populated Telok Ayer and Amoy Street soon became a popular location for clan associations.

Page 49
Bukit Pasoh Road
Bukit Pasoh boasts a concentration of shophouses built between the 1920s and 1930s when concrete was widely used in shophouse construction.

Page 50–51
Duxton Hill
Gazetted within the Chinatown Conservation District on 7 July 1989.
This was one of the first areas to be restored in its entirety. The area had been acquired by the Urban Redevelopment Authority for urban renewal and many of the buildings were vacant for some years. Instead, the buildings were sold by tender and restored by their new owners according to strict guidelines. The Duxton Hotel is a prominent landmark in the area.

KAMPONG GLAM
Kampong Glam was gazetted a Conservation District on 7 July 1989.

Page 52
Masjid Sultan, North Bridge Road
Built in 1924–28. Architect: Swan & Maclaren.
Gazetted a National Monument on 14 March 1975.
This mosque is not Singapore's oldest; that is a distinction which belongs to Masjid Omar Kampong Melaka which was built in Kampong Melaka in 1820. The present Masjid Sultan, which replaced an earlier structure dated circa 1824, has undergone several facelifts over the years. While there are many mosques and surau scattered over the island, Sultan Mosque continues to be a focal point for many Singapore Muslims.

Page 53
Sultan's Palace, Sultan Gate
Built circa 1836–1843. Architect unknown.
This was built as the residence of Sultan Ali Iskander Shah, son of the first Sultan of Singapore, and was probably built sometime between 1836 and 1843 on the site of a wood and attap structure. There has been some conjecture that it was designed by G.D. Coleman but this has never been proven.

Page 54
Shophouses, No. 321 Sultan Gate, at the corner of Beach Road
Built circa 1920s. Architect unknown.
This three-storey shophouse with its splayed corner, streamlined details and elegant fenestration is typical of Singapore's 1920s urban architecture. Beach Road was so named because it ran along the beach. A series of land reclamations, the first of them in the 1870s–1880s, moved the sea front to several kilometres distant.

Page 55
Shophouses, Kampong Glam
Built circa 1920s.
Kampong Glam retains the atmosphere of a village. The old-fashioned coffee shops still serve their regular patrons whilst tourists explore the well-known textile, basket and leather shops of Arab Street.

Page 58
Residential terraces, Kandahar Street
Here is a marvellous row of six residential terraces with magnificent plasterwork.

Page 59
Basket shops, corner of Arab Street and Beach Road
A leisurely stroll down Arab Street starts here. Shops further up specialize in textiles, batiks and semi-precious stones.

LITTLE INDIA AND BEYOND
Little India was gazetted a Conservation District on 7 July 1989.

Page 60
House of Madam Teo Hong Beng, No. 37 Kerbau Road
Built circa 1905. Architect unknown.
Here is an unusual structure: a classic example of Singapore's early 20th century, Straits Chinese, shophouse architecture, yet with the feel of a bungalow. It was built for Madam Teo Hong Beng, who married into the Tan Family, and would have originally contained richly carved and lacquered doors and furniture.

Page 61
Shophouses, Buffalo Road
Little India had by the 1880s already developed its distinctly Indian ambience. Not only were there Indian-run retail shops, but cattle and sheep traders, butchers and dairymen who had settled in the area because of the abundance of grassland and water. Thus the origins of the name "Buffalo Road" are not so difficult to ascertain.

Page 64
Residential Terraces, Nos. 10–44 Petain Road
Built early 1830s. Architect: J.K. Jackson for Mohamed bin Haji Omar.
Gazetted a Conservation Area on 25 October 1991.
This row of 18 ornate, heavily tiled, pastel-painted terrace houses ranks among the most homogeneous and intact extant today. The use of glazed ceramic tiles is particularly lavish and the colour scheme is reminiscent of Straits Chinese porcelain, kebayas, sarongs and beadwork.

Page 65
Shophouses, Veerasamy Road
Gazetted a Conservation Area on 25 October 1991.
These flamboyant and recently restored twins dramatically anchor the junction of Veerasamy Road and Jalan Besar.

Page 66-67
Shophouses, Syed Alwi Road
Built circa 1920.
Syed Alwi Road has examples of shophouse architecture at its most flamboyant. The oval-shaped windows at Nos. 61–69 are unique among Singapore's shophouses, although they bear a

striking resemblance to windows in Victoria Concert Hall.

Page 68
Coffee shop, Balestier Road
This is a varied and interesting street. In addition to medical clinics and building material suppliers are old-fashioned medicine and provision shops, fruit stalls and, of course, coffee shops. The road was named after Joseph Balestier who in 1836 was appointed the first American Consul to Singapore. He owned a large sugar plantation which he called Balestier Plain.

Page 69
Sun Yat Sen Villa, Tai Gin Road
Built in the 1880s, with renovations in 1938 and 1965. Gazetted a National Monument on 28 November 1994.
This delightful historic house was the headquarters of the Singapore branch of the Tung Ming Hin which was headed by Dr. Sun Yat Sen who plotted the overthrow of the Manchu Dynasty. Sun Yat Sen, who became the first provisional President of the Republic of China, stayed here on three occasions between 1900 and 1906. It is currently maintained by the Singapore Chinese Chamber of Commerce as a museum.

Page 70
Suburban terraces, corner of Lorong 19 and Lorong Bachok
Built circa 1929.
Geylang was gazetted a Conservation Area on 25 October 1991. Sikh guards — in plaster — guard the corner entrance to this elaborate and utterly unique concoction. There are also scenic panels beneath the upper-storey windows which depict a variety of subjects ranging from Chinese classical tales to a Straits soccer match and a rickshaw ride. There is another building similar to this at the corner of Balestier Road and Jalan Kemaman.

Page 71
The Red Bakery, East Coast Road
It seems as if this brightly painted building has been around forever and certainly the pavement is now several centimetres higher than the ground floor. Here bread and pastries are made the old-fashioned way. Patrons can sit at highly polished marble-top tables to sample the treats, sipping coffee and tea from the thick traditional coffee-shop cups.

CLASSIC TERRACES

Page 72–73
Residential terraces, Nos. 2 –16 Koon Seng Road
Built in the 1920s.

Within the Joo Chiat Conservation Area, gazetted 23 July 1993. Koon Seng Road is named after Cheong Koon Seng, an auctioneer and estate agent. The street is especially memorable in that it boasts two handsome facing rows of residential terraces near its junction with Joo Chiat Road.

Page 74–75
Residential terraces, Blair Road
Built in the 1920s.
Blair Road was gazetted a Conservation Area on 25 October 1991. The elaborate examples of residential terrace houses that line both sides of Blair Road were built in the 1920s as part of the general expansion of the town. Blair Road was laid out in 1900 and is named after John Blair, a senior officer of the Tanjong Pagar Dock Company in the 1880s. Many of the terraces here, as well as in the surrounding streets, have been renovated by individual owners. As a result, there is a renewed sense of vitality and prosperity in the area.

Page 77
Residential terrace, No. 77 Emerald Hill Road
Built in 1925. Architect: R.T. Rajoo.
Emerald Hill was gazetted a Conservation Area on 7 July 1989. The houses of Emerald Hill have been well documented by various researchers, especially retired architect Lee Kip Lin. This particular house was built for Low Koon Yee, from a well-established Teochew Straits Chinese family. It is one of a block of terraces, Nos. 71–85, owned by Low who also owned the adjacent block, Nos. 53–69. Until 1990 the house was lived-in by descendants of the original owner. The new owner restored the interior with loving care and a remarkable attention to detail.

Page 78-79
Residential terraces, Nos. 39–45 Emerald Hill Road
Built in 1905. Architect: G.A. Fernandez & Co. for Goh Kee Hoon with original drawings signed by Wan Mohammed Kassim. Emerald Hill was gazetted a Conservation Area on 7 July 1989. "Generous" and "imposing" are the two words that seem to sum up most accurately this handsome row of three-storey terraces. Particularly interesting is No. 41 which has been exquisitely restored by owners who were determined to return the house as nearly as possible to its original condition.

BUNGALOWS AND PARKS

Page 80
Bungalow, Mountbatten Road
Built circa 1910.

A typical example of the early 20th century suburban bungalows built for well-to-do Chinese families in areas like Katong.

Page 81
Boscombe, No. 40 Nassim Road
Built in 1905. Architects: Tomlinson and Lermit.
Nassim Road was gazetted a Conservation Area on 29 November 1991.
Nassim Road is one of Singapore's most beautiful roads. Originally called New Government Road, it was later named after well-known businessman Israel Nassim. Boscombe was built for William Dunman, manager of the 160-hectare (400-acre) Grove Estate coconut plantation and sold in 1929 to Edmond Adler, an American businessman. It survived World War II unscathed and was acquired by the United States government to serve as the residence of the American Consul. When the post was elevated to Embassy status in 1965, the house became the residence of the Naval Attaché until it was sold in 1990. By then, its history had been meticulously charted by its various inhabitants.

Page 82–83
Eden Hall, Residence of the British High Commissioner, Nassim Road
Built in 1904.
Eden Hall was built in the late Edwardian Classical Revival style for wealthy Jewish businessman E.S. Manasseh. Manasseh leased the house to a Mrs. Campbell who ran it as a boarding house, then took possession of it in 1918 and lived in it until his death in 1945. Today it is the residence of the British High Commissioner. There is a splendid dining room and a delightful garden room which overlooks a paved terrace. The gardens are magnificent. In 1993 extensive restoration work was carried out that, among other things, revealed a cast-iron balustrade along the main staircase emblazoned with the initial "M".

Page 84
Alkaff Mansion, Telok Blangah Green
Built circa 1920.
The Alkaffs were a wealthy and prominent Arab trading family originally from South Yemen who built this hill-top house as a family retreat in order to entertain guests and visitors. It was abandoned after World War II, fell into a state of disrepair and was then "rediscovered" and acquired by the Singapore Tourist Promotion Board in 1986. Now beautifully restored and furnished, it is a restaurant and venue for functions.

Bungalow, Pulau Ubin
Built circa 1930s.
This bungalow with distinct Tudor overtones and its own pier is reached by ferry from Changi Point. It was built as a weekend retreat for a British trading company then sold to a Singaporean family which has retained its rustic charms.

Page 85
Golden Bell (Danish Seaman's Church), No. 9 Pender Road
Built in 1909. Architect: Moh Wee Teck.

Standing on a hill once known as Mount Washington, Golden Bell was commissioned by Tan Boon Liat, the grandson of Tan Tock Seng who was the leader of the early Hokkien community and benefactor of the hospital which bears his name. It is now the Danish Seaman's church and mission.

Page 88–91
Black-and-White houses, Goodwood Park, Botanical Gardens, Ridley Park and Alexandra Park
Built in the early 1900s–1930s. Architects: colonial engineers in the Public Works Department.

Black-and-White houses were built for colonial administrators, senior army officers and prospering businessmen. The architecture combined nostalgic memories of Tudor cottages with an excellent understanding of the tropical climate and a sensitivity to vernacular Malay architecture. The houses were invariably planned for spacious park-like settings so many are now surrounded by large mature trees. The half-timber construction is generally confined to the second storey while the first storey has load-bearing brick walls, piers and columns. The houses are government-owned, maintained by the Urban Development and Management Corporation (UDMC) and rented out.

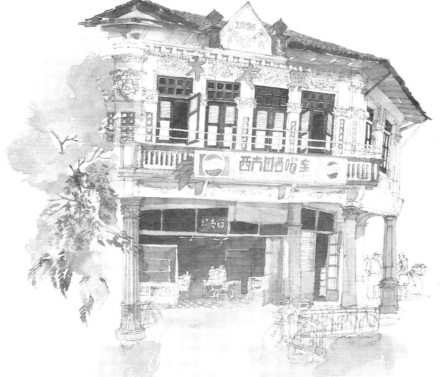

1958 Chophouse at the corner of
Bukit Timah & Cluny Road, Singapore

The old coffee shop on the corner of Cluny Road and Bukit Timah Road was the first building I painted here and it is with a sense of personal pleasure that this beautiful example of Straits Chinese architecture, together with all the other buildings in this book, has been preserved for future generations of Singaporeans as part of their history.

Graham Byfield.